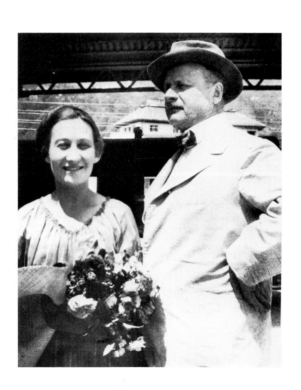

THE BLUE FOUR
GALKA SCHEYER COLLECTION

NORTON SIMON MUSEUM OF ART AT PASADENA

EDITED BY SARA CAMPBELL

This project is supported by a grant from the National Endowment for the Arts in Washington, D.C., a Federal agency.

Frontispiece: Galka Scheyer with Alexei Jawlensky

Designed in Los Angeles by Lilli Cristin. All type set in Futura by Ad Compositors, Los Angeles. Printed in Switzerland by Conzett and Huber.

Library of Congress Cataloging in Publication Data

Norton Simon Museum of Art at Pasadena.
The Blue Four Galka Scheyer Collection, Norton Simon Museum of Art at Pasadena.

1. Blaue Vier (Group of artists) — Catalogs.
2. Expressionism (Art) — Germany — Catalogs. 3. Art, Modern — 20th century — Germany — Catalogs. 4. Art — Pasadena, Calif. — Catalogs. 5. Scheyer, Galka E. — Art collections. 6. Norton Simon Museum of Art at Pasadena.
I. Campbell, Sara, 1941- II. Title.
N6868.5.E9N67 1976 709'.04 76-13890
ISBN 0-915776-01-4 pbk.

THE CATALOG IS ORGANIZED CHRONOLOGICALLY BY MEDIUM. THE ILLUSTRATIONS ARE GROUPED ACCORDING TO SUBJECT MATTER OR THEME.

CONTENTS

ACKNOWLEDGEMENTS

6

The museum is very fortunate that several people have generously donated their time over the years to organizing hundreds of documents and letters: in particular Ann Barrett and Katie Schwarzenbach, and especially Elizabeth Elliott for her cheerful perseverance and attention to detail. I would like to thank Frank J. Young for deciphering and translating much of the material in the collection. It is a pleasure to acknowledge the help of Mme. Lette Valeska, whose professional expertise and kind assistance have greatly aided the museum's curatorial staff for over twenty years. I would like also to express my gratitude to Jan Stedman and Jim Druzik for their generous editorial assistance, and to Diane Tucker and Amy Navratil for their patient secretarial help at every step along the way.

The museum is indebted to Gretchen Taylor Glicksman for supplying the Archive with a thorough provenance and bibliography for each Blue Four work of art in the collection. In addition Ms. Glicksman has organized and carefully compiled all of the pertinent data on the works of art which are listed herein. This, and the constant encouragement and financial support from the Pasadena Art Alliance has made it possible for the museum to produce this catalogue.

Sara Campbell

FOREWORD

When Galka Scheyer arrived in America over fifty years ago as the repre-
sentative of the Blue Four — Lyonel Feininger, Alexei Jawlensky, Wassily
Kandinsky and Paul Klee — they were virtually unknown in this country.
Today their works are the foundation of noted modern art collections
throughout the world.

In April 1953 the Norton Simon Museum of Art at Pasadena, then the
Pasadena Art Institute, became trustee of The Blue Four Galka Scheyer
Collection. The collection contains over four hundred works by the Blue
Four and other artists from Galka Scheyer's personal collection as well as
those works given to the Museum by friends of Mme. Scheyer since the
establishment of the trust.

In 1961, Scheyer's lifelong friend, Mme. Lette Valeska, proposed the
formation of the Galka Scheyer Blue Four Archive, which was established
with the financial support of the Pasadena Art Alliance. The Archive
provides an important adjunct to The Blue Four Galka Scheyer Collection,
containing over eight hundred pieces of correspondence between Scheyer
and the artists, and other documents which serve as record of Scheyer's
untiring interest in modern art.

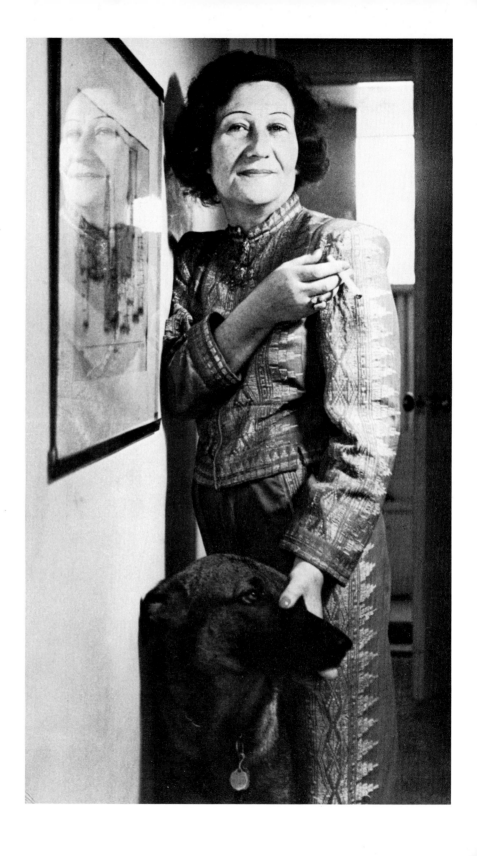

GALKA SCHEYER

Galka Scheyer was born Emmy Scheyer on April 15, 1889, in Brunswick,
Germany. Life in the Scheyer household was financially comfortable and
Galka's early formal education included private tutoring in painting as
well as several years of piano study at the local conservatory. Later at uni-
versity she continued her art and music education, first in London, then
at the Ecole des Beaux-Arts and the Paris Conservatory.

After her studies in Paris, Scheyer returned for a time to Germany, but
shortly after the beginning of World War I she moved to Brussels to pur-
sue her career as an artist. However, the hardships encountered during the
war years and her own lack of progress as a painter discouraged her, and in
1916 she left for Switzerland to find inspiration among the expatriate art-
ists there who had fled the war.

Soon after her arrival in Switzerland, she attended an exhibition in
Lausanne where she discovered a painting, *The Hunchback*, by the
Russian Alexei Jawlensky. So moved was Scheyer by the work that she
visited Jawlensky at his home in the village of St. Prex. There she was
introduced to Jawlensky's early portraits and the landscapes begun since
his emigration to Switzerland two years earlier.

Overwhelmed by Jawlensky's expression of spirituality and color,
Scheyer determined from that moment to abandon her own aspirations as
an artist and to devote herself to encouraging and promoting the work of
Jawlensky. She spent the next months with the artist and his family, served
for a time as model for a new group of portraits, and became a dominant
force in Jawlensky's life and work.

Although their intense friendship was to endure for twenty-five years
until Jawlensky's death in 1941, family pressure to return to more comfor-
table circumstances took Scheyer back to Germany in 1919. It was during
this period of separation, in December 1920, that Jawlensky wrote to
Scheyer of a dream he experienced in which she appeared to him in the
form of a bird. From that time on, Jawlensky referred to her as "Galka,"
the Russian for black bird, and it was this name which Scheyer took as her
own for the remainder of her life.

At about the time of Scheyer's return to Germany, a new institution was
being formed in Weimar under the leadership of Walter Gropius — the

Bauhaus. Under its roof a group of master artists and craftsmen were brought together whose purpose was to merge art and technology and to lay the foundation for what Gropius termed the new building of the future.

The first painter who came to Weimar was Lyonel Feininger. He designed the cover for the Bauhaus Manifesto written by Gropius in 1919 and as Master of Form headed the art faculty and the technical or form workshops. Although American born, Feininger enjoyed recognition as an artist in Germany, and his work was represented in several noted collections. The son of concert artists, Feininger had come to Germany at sixteen to continue his musical education in 1887. He enrolled at the School of Applied Arts in Hamburg and although music was to remain an important force in his life, his interest soon turned to art. By 1911 he had joined the Cubists in Paris and two years later exhibited with the Blue Rider group in Berlin.

This latter association influenced Feininger's Bauhaus appointments and in 1921 Paul Klee, a friend from the Blue Rider days, joined the faculty. The following year Wassily Kandinsky, who along with Franz Marc co-founded the Blue Rider, also came to Weimar.

Galka Scheyer had first met Lily and Paul Klee during the time spent with Jawlensky in Switzerland. Both Klees were accomplished musicians and this interest as well as Scheyer's admiration for Klee's work and their mutual friendship with Jawlensky, brought them together once again. Scheyer became a frequent guest at their new quarters in Weimar and in this way became acquainted with Feininger.

Although archival documents do not indicate whether Scheyer had actually met Kandinsky prior to her visits to the Bauhaus, his long friendship with Jawlensky was certainly known to her, an alliance which in 1909 had brought Kandinsky and Jawlensky to form The New Association of Munich Artists, forerunner of the Blue Rider.

During the early Weimar years, Scheyer's association with Klee, Feininger, and Kandinsky was an informal one. Although she did agent occasional sales for them, her main efforts continued as before to be devoted to Jawlensky. She lectured on his work at the Bauhaus and negotiated sales and exhibitions throughout Germany. It was not until 1924 when an

opportunity arose for Scheyer to travel to the United States that the concept of uniting all four artists into a more official relationship came into being.

Warned by Feininger that America was at that time still hopelessly enamoured with the work of the Impressionists and Fauves — an inclination made the more certain by the success of the New York Matisse retrospective that year — it was determined that initial exhibition possibilities for Scheyer's moderns would be greater if they were presented as a group. Feininger offered "The Four" as their collective name for America, since The Big Four, a term given the four major U.S. railways, had a timely and powerful image. The *Blue* Four emerged from this, an identification which not only recalled their former Blue Rider association, but which for Scheyer represented a sense of spirituality which symbolically united the four in a common bond.

On March 31, 1924, Lyonel Feininger, Wassily Kandinsky, Paul Klee, and Alexei Jawlensky signed an agreement in Weimar designating Galka Scheyer as their American representative. It was further agreed that fifty per cent of sale proceeds would be paid to the artist, thirty per cent to Scheyer as agent, and the remaining twenty per cent allocated to a common trust held by The Blue Four. In April of that year Scheyer held her first Blue Four exhibition in Germany in a private home, and the following month she sailed for America with the work of her four "blue kings."

But despite the letters of introduction from Feininger and others which preceded her arrival in New York, Scheyer found America's reception of her Blue Four unfavorable. By year's end she had sold but one work. This lack of commercial success did not discourage her, however. Enthusiastic about life in the New York of the 1920's, Scheyer set about making contacts with galleries and universities through her new acquaintances, determined the Americans would soon share her zeal for the Blue Four. To supplement the living allowance she received from her family, she taught private school children "Creative and Imaginative Painting," a method of free expression she had developed earlier in Europe. She also gave occasional Blue Four lectures at Columbia, and in 1925 her first American exhibition was held at The Daniel Gallery in Manhattan.

Yet despite efforts to educate her new public, the sales needed by her artists back in Europe were not forthcoming. Thus in the summer of 1925, in hope that the West would prove more receptive than New York had been, Scheyer travelled across country to California, lecturing about the artists along the way.

It was in San Francisco that Scheyer at last found the response she had been seeking for her Blue Four. During the next three years she gave lectures and arranged exhibitions of their work in the San Francisco area, as well as in Los Angeles, Portland, and Spokane.

Meanwhile inflation had hit Europe, bringing with it the rise to power of the National Socialists in Germany. The new government in Weimar, controlled by middle-class interests, grew less hospitable in its attitude toward the Bauhaus, and in 1925 withdrew its financial support. Undeterred, however, Gropius and his followers moved to Dessau and the next year his newly designed studios and living quarters were officially inaugurated.

Klee and Kandinsky moved to the Dessau studios at the end of 1925, and were later rejoined by Feininger, who had left the Bauhaus the year before to pursue his own work. Their letters to Scheyer in America during this period are highly personal accounts of the large and small events of their lives.

"You cannot imagine how the Dessau homes are admired," wrote Feininger. "On Sunday 10,000 people will come by and stand in front of the row of houses." Indeed, the interest created both in Europe and America had brought a procession of visitors who day and night peered into their windows for a closer look at the unusual creatures who inhabited the strange architecture.

In his studio Kandinsky was completing his Bauhaus book, *Point and Line to Plane*. "For weeks I have been working on my book. . . . It is a purely theoretical work which gives me great pleasure . . . [and] is a comprehensive expansion of my thoughts on the Spiritual . . . already outlined eleven years ago on the Bodensee."

Meanwhile in Wiesbaden, Jawlensky was becoming, as he put it, "a celebrity." There were exhibitions throughout Germany and his work was

regularly published. This long-awaited status did not ensure his financial
security, however. Even his greatest supporters were reluctant to buy in view of the economic uncertainty which prevailed, and he continued to be burdened with money worries.

In the spring of 1928, Scheyer visited Europe for the first time since her departure for America. At the invitation of the International Art Congress in Prague, she lectured on her Creative and Imaginative Painting teaching method, and also served as conference representative for the Oakland Art Gallery. Reunited again with her Blue Four, she gathered new works for America and assisted in the arrangements for their collective exhibition to be held at the Möller Gallery in Berlin the next year.

The five intervening years between this and Scheyer's next visit to Germany were marked by the all too familiar events which first brought Europe and then America to economic collapse. Yet, ironically, this period was the most successful for Scheyer.

In 1929 the Oakland Art Gallery opened a travelling Blue Four exhibition sponsored by the Western Association of Art Museums. This was followed by a Braxton Gallery show in Hollywood the next year; and in 1931 an exhibition at the Legion of Honor in San Francisco, another show at Oakland, and at the invitation of Diego Rivera, one at the Biblioteca Nacional in Mexico City.

1931 also marked the year of Feininger's 60th birthday and large retrospectives of his work were held in Essen and at the Crown Prince Palace at Berlin. The same year Klee left the Bauhaus for an appointment at the academy in Dusseldorf. Regrettably, 1931 was also the beginning of a series of lengthy bouts with arthritis which would keep Jawlensky an invalid for most of his life.

Meanwhile, Scheyer had left San Francisco and moved to Hollywood, renting R.M. Schindler's Chase House, where for the first time she had space to exhibit the works she had collected over the years. In a letter to Feininger she notes her efforts at cataloguing her personal collection of then over three hundred works, which in addition to the Blue Four included works by Archipenko, Lissitzky, Kokoschka, Marc, Dix, Moholy-Nagy, Nolde, and Schlemmer.

In 1933 Scheyer returned to Europe to find a radically changed Germany. The country which she had known and which had given life to some of the most sophisticated scientific and artistic expression in Europe was now guided by a new order. Academies throughout the country were being forced to close. Even Berlin, once the heart of Germany's cultural life, began to give way. The Bauhaus, having been forced to leave Dessau the year before and take up residence at an old Berlin telephone factory site, was again closed. In a note to Scheyer on her arrival, Kandinsky wrote on April 12th: "A house search was undertaken yesterday at the Bauhaus: the police in Dessau told the local police that five crates of illegal writings could be found in the Bauhaus. Of course, nothing was found but, nonetheless, the house has been locked up and is still closed today." And in August: "We ourselves dissolved the Bauhaus and so it no longer exists — it survived for fourteen years. . . . For the entire summer semester [it] was shut and for this reason its income failed."

Soon thereafter Kandinsky moved to Neuilly-sur-Seine near Paris. Feininger remained in Berlin entrusting his fate to his American citizenship until he could arrange to leave Europe. Klee, having been charged publicly in the press as a Galician Jew and ordered to prove his Aryan ancestry, returned to Switzerland.

In light of these events, Scheyer cut short her visit, gathered what new Blue Four works she could, and left again for America. It was the last time she saw Germany.

It has often been argued that had the Bauhaus never been formed, its now famous faculty would have gained recognition independent of that association. Yet it was during the Bauhaus years that artists like Klee and Kandinsky gained notability and that Lyonel Feininger became firmly established as the "painter-architect of his time." The Bauhaus had also proved a significant identification for them as members of the Blue Four in America, and with its closure similarly dissolved it.

This circumstance and the fact that each had now gained a certain reputation independently, caused Scheyer to exhibit them individually for the first time. The house designed for her by Richard Neutra in 1933 in the

Hollywood Hills was now close to being completed, and in addition to gallery and museum exhibitions she began to conduct Blue Four lectures and show their work in her home. Scheyer wrote to Kandinsky: "I have had two exhibits and lectures and [to] think that I will soon be living in my new house on Blue Heights Drive. . . . I picked this name myself and the City accepted it."

During the next several years the economic crisis which no one thought could worsen turned into worldwide depression. The art market likewise suffered. In Europe, the hardest hit, collectors who could still afford to buy were able to demand prices which were often less than twenty-five per cent of former value. This situation created a disastrous effect on the American art market and much of the remaining correspondence between Scheyer and her artists is given to business particulars. One such letter, perhaps the last which Klee personally wrote to Scheyer, also provides a rare illustration of the whimsical humor so characteristic of Klee's personality: "If you had written: 'Beware of selling out, it is high time you raised your prices!' — well, then I would have wired: 'Yes, of course, immediately.' But you have asked much stricter questions . . . which almost read like an old poem in the didactic style. I have submitted them to some Learned Authorities, but no one could decode them. Li Tai Po is dead."

Yet despite the frequent monetary devaluations and their disappointment in Hollywood's lack of interest in art, Scheyer continued as before on behalf of her artists. As the threatening political climate brought Europe closer to war, Scheyer tried to persuade her friends to join her in America. A guest apartment atop her house had been added to serve as temporary quarters. But neither Kandinsky nor Klee were confident of their English — a factor which had prevented them from accepting earlier teaching offers in America — and Klee had been bedridden for a year by acute illness. Jawlensky's health too had rapidly deteriorated, a condition further complicated by various experimental treatments. And in spite of the monthly stipend he received from the Jawlensky Society and efforts by Scheyer and the other Blue Four artists on his behalf, he remained in Wiesbaden in utter poverty.

Of the four, only Feininger would get to America. At the invitation of Mills College in Oakland, California, Feininger taught summer session in 1936. He returned again the following summer and thereafter took up permanent residence in New York until his death in 1956.

After 1939, contact between Scheyer and her artists in Europe became increasingly difficult. The following year word of Paul Klee's death came, and in 1941 Jawlensky died.

Although Kandinsky survived the fall of France, he was not to live out the war, and in 1944 he died at Neuilly-sur-Seine. Precisely one year later, Scheyer's struggle with cancer ended with her own death on December 13, 1945.

Galka Scheyer had devoted twenty years acquainting America with the art of the Blue Four and other moderns, a career marked by a spirit which is perhaps best defined in a letter written by Lyonel Feininger to Scheyer on the day of her death: "What a sad little note.---Galka is very ill, Galka doesn't listen to music, nor does she read; only still she can look a little at pictures; pictures have always made out her chief happiness, her great object in living."

Jan Stedman

THE COLLECTION

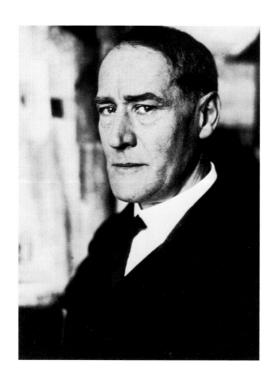

LYONEL FEININGER

American 1871-1956

WATERCOLORS

1 MELLINGEN IV 1916
Watercolor, opaque watercolor, and ink on laid paper; 9¾ x 12⅝ in (24.5 x 31.9 cm)
Signed and inscribed, lower left: *Feininger/ Das Dichten ist schwer, das Malen um so mehr* [Poetry is difficult, but painting all the more]; inscribed, lower center: *MELLINGEN IV*; dated and inscribed, lower right: *Sunday September 17, 1916/ ihrer 1. Emmy von Feiningers*
(53.222) Illus. p. 20

2 ASCENDING BALLOON (Aufsteigender Ballon) 1920
Watercolor and ink on laid paper; 9¼ x 11⅞ in (23.5 x 30.2 cm)
Signed, lower left: *Feininger;* inscribed, lower center: *Aufsteigender Ballon;* dated, lower right: *1920;* inscribed, signed, and dated on former mount: *Wahrhaftig soll ihnen Weimar nur gute und liebe Erinnerung sein!/ L. Feininger/ Weimar/ d. 30 VI* [Truly Weimar must be only a *good* and pleasant memory!]
(53.221) Illus. p. 21

3 RIVER BANK (Flussufer) 1932
Watercolor and ink on laid paper; 12¼ x 18⅜ in (31.0 x 46.7 cm) (irreg.)
Signed and inscribed, lower left: *Feininger fluss ufer;* dated, lower right: *22 8 32;* inscribed and dated, verso: *To his little friend, from Papileo, Mar. 25. '33*
(53.243) Illus. p. 22

4 UNTITLED (Sailing Ship) 1933
Watercolor and ink on laid paper; 7⅝ x 7⅞ in (19.2 x 19.8 cm)
Signed, lower left: *Feininger;* dated, lower right: *18 9 33;* inscribed, verso: *To his lil Friend, wishing a Happy New Year! from Papileo*
(53.248) Illus. p. 23

5 PEACEFUL VOYAGE III (Friedliche Schiffahrt III) 1933
Watercolor and ink on flecked laid paper; 10⅞ x 11¼ in (27.6 x 28.6 cm)
Signed and inscribed, lower left: *Feininger: friedliche Schiffahrt III;* dated, lower right: *3 10 33;* inscribed along lower edge: *To his Little Friend Galka Emmy, from Papileo, zur Erinnerung an die Zeit, Juni, 1936* [In memory of the time, June, 1936]
(53.244) Illus. p. 24

6 FULL-RIGGED SHIP (Vollschiff) 1933
Watercolor and ink on laid paper; 8 x 10½ in (20.3 x 26.7 cm)
Signed and inscribed, lower left: *Feininger: Vollschiff;* dated, lower right: *9 10 33;* inscribed and signed along lower edge: *"la peinture à l'huile, c'est plus difficile; la peinture à l'eau, c'est peut-être plus beau!" Feininger* [Oil painting is more difficult; watercolor painting is perhaps more beautiful!]
(53.245) Illus. p. 25

7 UNTITLED (Sailing Ship) 1933
Watercolor and ink on flecked laid paper; 8⅞ x 12⅝ in (22.4 x 32.1 cm)
Signed and dated, lower left: *Feininger: 1933;* inscribed, lower right: *EMY, with all good wishes!*
(53.249) Illus. p. 26

8 UNTITLED (Blue Skyscrapers) 1937
Watercolor and ink on laid paper; 12¼ x 9⅝ in (31.1 x 24.3 cm)
Signed, lower left: *Feininger;* dated, lower right: *22.10.37;* inscribed along lower edge: *To Galka from Julia & Papileo*
(53.247) Illus. p. 28

20

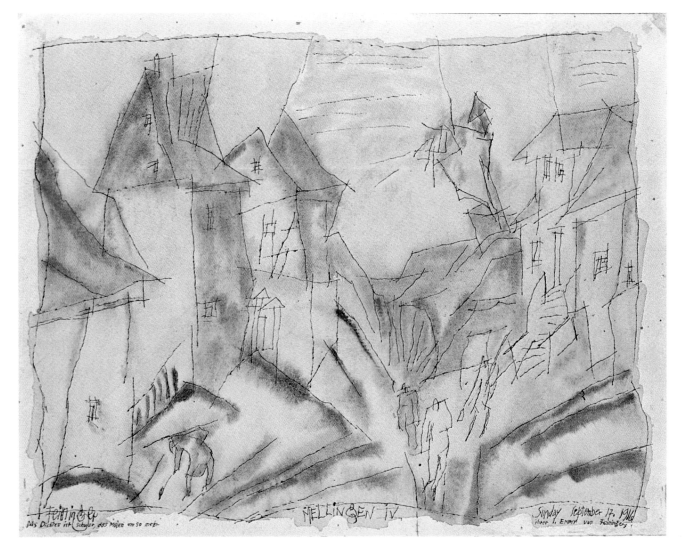

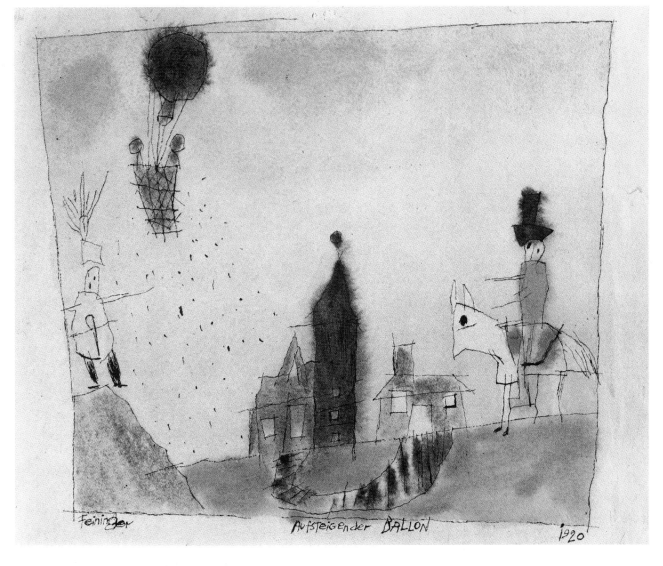

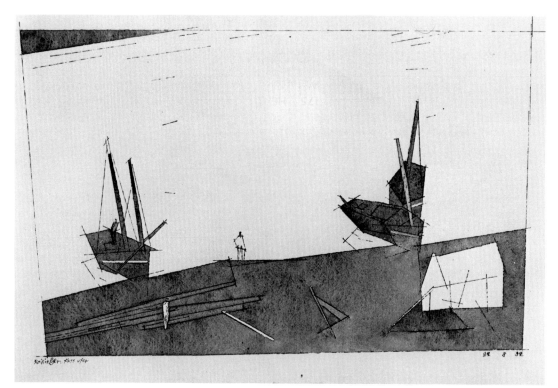

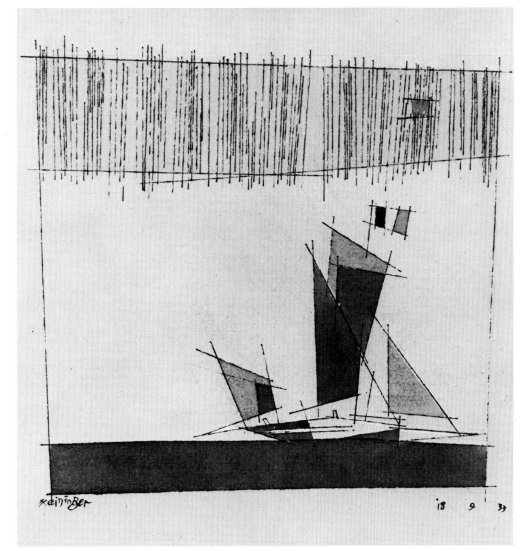

24

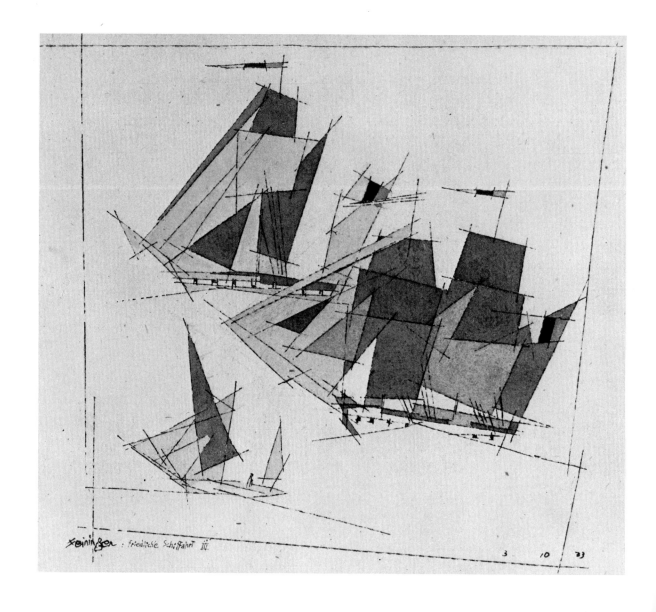

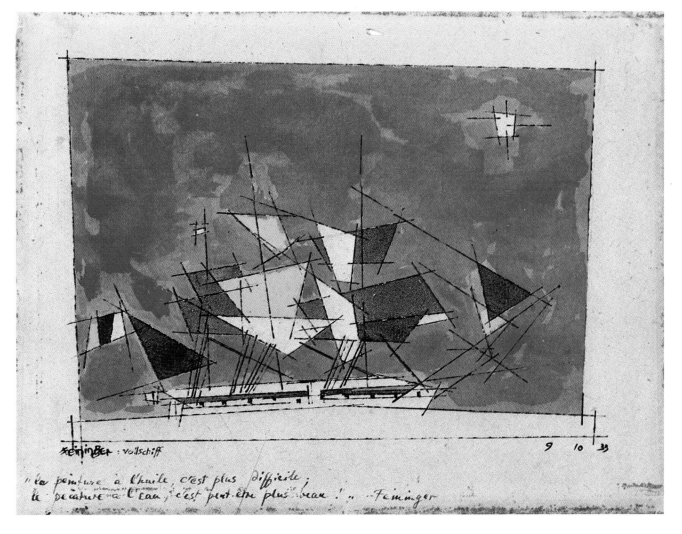

Feininger : Vollschiff 9 10 33

"la peinture à l'huile, c'est plus difficile;
la peinture à l'eau, c'est peut-être plus beau!" —Feininger

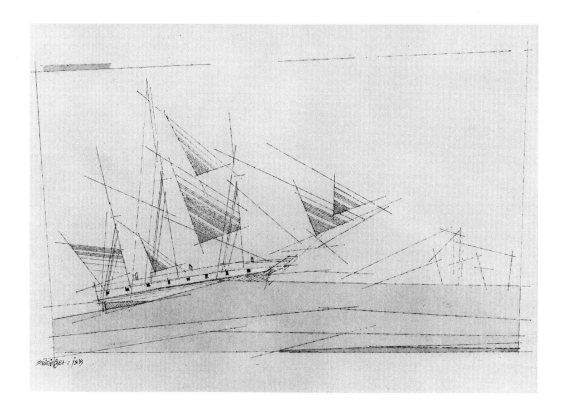

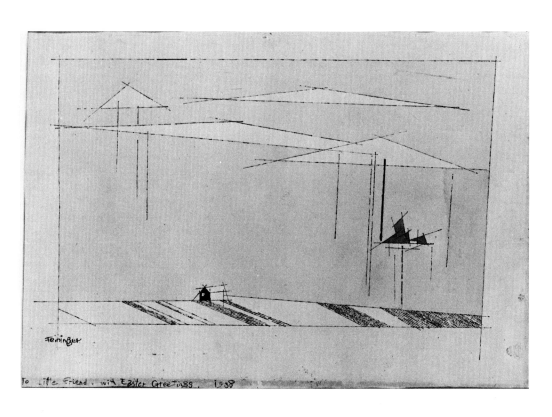

7 Feininger Untitled (Sailing Ship)
1933

9 Feininger Untitled (Blue Shore)
ca. 1938

9 UNTITLED (Blue Shore) ca. 1938
Watercolor and ink on laid paper;
8⅛ x 11¾ in (20.6 x 29.9 cm)
Signed, lower left: *Feininger*; in-
scribed and dated along lower mar-
gin: *To Little Friend, with Easter
Greetings, 1938*
(53.246) Illus. p. 26

10 UNTITLED ca. 1945
Watercolor, silver pigment and ink
on laid paper; 8¾ x 12½ in (22.1
x 31.7 cm)
Signed, inscribed, and dated, lower
left: *Papileo for Galka/Jan. 11.
1945*; verso: ink drawing of a simi-
lar scene
(53.168) Illus. p. 29

DRAWINGS

11 CLOUD (Wolke) 1923
Ink on flecked laid paper; 10⅞ x
15¾ in (27.6 x 40.0 cm)
Signed, lower left: *Feininger*; in-
scribed, lower center: *Wolke*; dated,
lower right: *Freitag d. 13. IV. 1923*
[Friday, the 13th of April 1923]
(53.242) Illus. p. 22

ETCHINGS

12 VILLAGE (Dorf) 1911
Etching on laid paper; impression,

4¾ x 7¾ in (12.0 x 19.7 cm); sheet,
10¹⁵/₁₆ x 16 in (27.8 x 40.6 cm)
Signed and dated, lower left: *Lyonel
Feininger/1911*; inscribed, lower
right: *Dorf*
(53.175)

13 THE MAN WITH THE
WHEEL (Der Mann mit dem Rad)
1911
Etching on wove paper; impres-
sion, 5⁷/₁₆ x 8⁹/₁₆ in (13.8 x 21.8 cm);
sheet, 9⅝ x 12¹¹/₁₆ in (24.4 x 32.4
cm)
Signed in the plate, lower left:
Leinoel Einfinger; signed and dated
in the margin, lower left: *Lyonel
Feininger/1911*; inscribed, lower
right: *der Mann mit dem Rad*
(53.178)

14 STREET IN BOURG-LA-
REINE 1911
Etching on yellow simulated laid
paper; impression, 5½ x 4⁵/₁₆ in
(14.0 x 10.9 cm); sheet, 13⁷/₁₆ x 9¹³/₁₆
in (34.1 x 25.0 cm)
Signed in the plate, upper right:
Leinoel Einfinger; signed in the
margin, lower left: *Lyonel Feinin-
ger*; inscribed, lower right: *Street
in Bourg-la-Reine*
(53.180)

15 THE SUNRISE HOUR 1911 27
Etching on simulated laid paper;
impression, 6¼ x 9⅜ in (15.9 x
23.8 cm); sheet, 9¾ x 13⁷/₁₆ in (24.8
x 34.1 cm)
Signed and dated in the plate, low-
er right: *Leinoel Einfinger/1911*;
signed and inscribed in the margin,
lower left: *Lyonel Feininger*; lower
right: *The Sunrise Hour*
(53.179)

16 THE DISPARAGERS 1911
Etching on simulated laid paper;
impression, 8⁹/₁₆ x 10⅝ in (21.7 x
27.0 cm); sheet, 13⅝ x 19½ in (34.6
x 49.5 cm)
Signed, inscribed, and dated in the
plate, lower left: *Feininger*; lower
center: *The Disparagers*; lower
right: *Friday 22 Sept. 1911*; signed,
dated, and inscribed in the margin,
lower left: *Lyonel Feininger/1911*;
lower right: *The Disparagers*
(53.169)

17 NIEDERGRUNSTEDT 1911
Etching on simulated laid paper;
impression, 5½ x 8¹¹/₁₆ in (14.0 x
22.1 cm); sheet, 12⅞ x 14⅞ in (32.7
x 37.8 cm)
Signed in the plate, lower left: *Lei-
noel Einfinger*; signed, dated, and
inscribed in the margin, lower left:

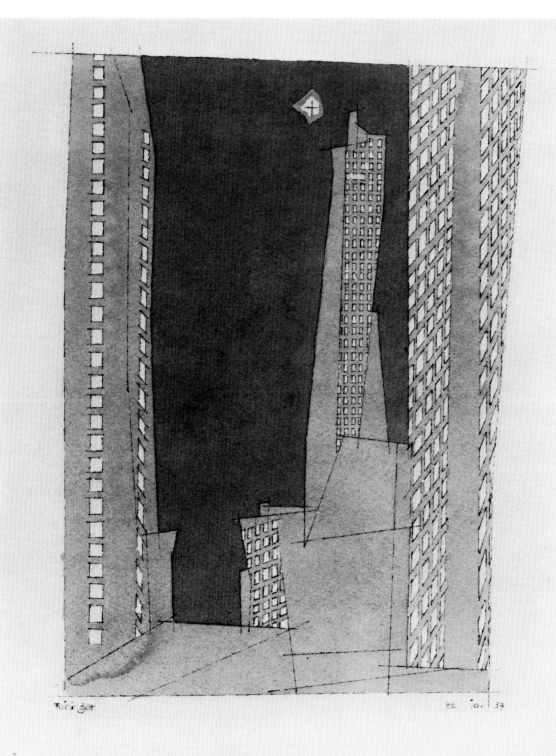

Feininger

42. 10. 37

To Galka from Julia & Papileo

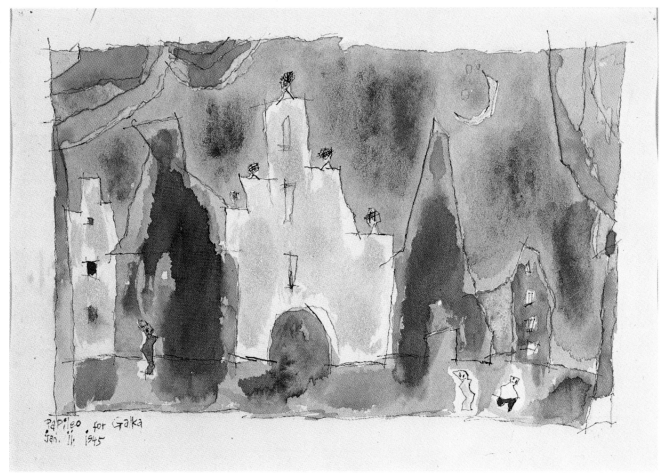

Lyonel Feininger/1911; lower right: *Niedergrunstedt*
(53.177)

18 THE PRIVATEERSMAN 1912
Etching and drypoint on simulated laid paper; impression, $5^7/_{16}$ x $8^7/_{16}$ in (13.8 x 21.4 cm); sheet, $9^{15}/_{16}$ x $13^3/_8$ in (25.4 x 34.0 cm)
Signed in the plate, lower right: *Leinoel Einfinger*; signed, dated, and inscribed in the margin, lower left: *Lyonel Feininger/1912*; lower right: *The Privateersman*
(53.172)

19 THE EVENING GREETING 1917
Etching on simulated laid paper; impression, $5^1/_2$ x $8^9/_{16}$ in (14.0 x 21.7 cm); sheet, 10 x $13^5/_{16}$ in (25.4 x 33.7 cm)
Signed, dated, and inscribed, lower left: *Lyonel Feininger/1917*; lower right: *The evening greeting*
(53.176)

WOODCUTS

Note: Feininger devised a numbering system for his woodcuts, which was usually noted in the middle of the bottom margin. The first two digits indicate the year in which the block was cut, the last two or three the sequence of the print within that year. For example, the work number "1827" indicates that the work was the 27th block cut in 1918.

20 TALL PARIS HOUSES (Pariser hohe Häuser) Block cut 1918
Woodcut on thin, flecked paper; proof, $5^1/_4$ x $4^1/_8$ in (13.4 x 10.5 cm); sheet, $8^5/_8$ x 11 in (21.9 x 28.0 cm)
Signed in the margin, lower left: *Lyonel Feininger*; numbered, lower center: *1811*
(53.181)

21 LITTLE HUNTER'S LODGE (Die kleine Försterei) Block cut 1918
Woodcut on green tissue paper; proof, $4^1/_8$ x $3^7/_8$ in (10.5 x 9.9 cm); sheet, $5^1/_4$ x 5 in (13.4 x 12.7 cm)
Signed and inscribed in the margin, lower left: *Lyonel Feininger/ ᵟ*; numbered, lower center: *1816*
(53.225)

22 LITTLE HUNTER'S LODGE (Die kleine Försterei) Block cut 1918
Woodcut on thin paper, mounted on heavy paper; proof, $4^1/_8$ x $3^7/_8$ in (10.5 x 9.9 cm); sheet, $6^3/_{16}$ x $4^7/_8$ in (15.7 x 12.4 cm); mount, $9^7/_8$ x $6^{15}/_{16}$ in (25.1 x 17.6 cm)

Signed and inscribed in the margin, lower left: *Lyonel Feininger/ ᵟ*; numbered, lower center: *1816*
(53.184)

23 LITTLE HUNTER'S LODGE (Die kleine Försterei) Block cut 1918
Woodcut on paper; proof, $4^1/_8$ x $3^7/_8$ in (10.5 x 9.9 cm); sheet, 11 x $8^1/_2$ in (28.0 x 21.6 cm)
Feininger's work number 1816. Proof occurs on page 2 of a two-page typewritten letter from Lyonel Feininger to Galka Scheyer, signed and dated July 18, 1942.
(53.627)

24 THUNDERSHOWER (Gewitterregen) Block cut 1918
Woodcut on yellow tissue paper; proof, $6^5/_{16}$ x $6^3/_4$ in (16.0 x 17.2 cm) (irreg.); sheet, $9^1/_{16}$ x $11^9/_{16}$ in (23.0 x 29.4 cm)
Signed in the margin, lower left: *Lyonel Feininger*; numbered, lower center: *1818*; inscribed, lower right: *Gewitterregen*
(53.187)

25 THE SHIP OWNER, 1 (Der Reeder, 1) Block cut 1918
Woodcut on green tissue paper; proof, $4^7/_{16}$ x $5^3/_4$ in (11.3 x 14.6 cm); sheet, $7^3/_{16}$ x $9^3/_4$ in (18.3 x 24.8 cm)

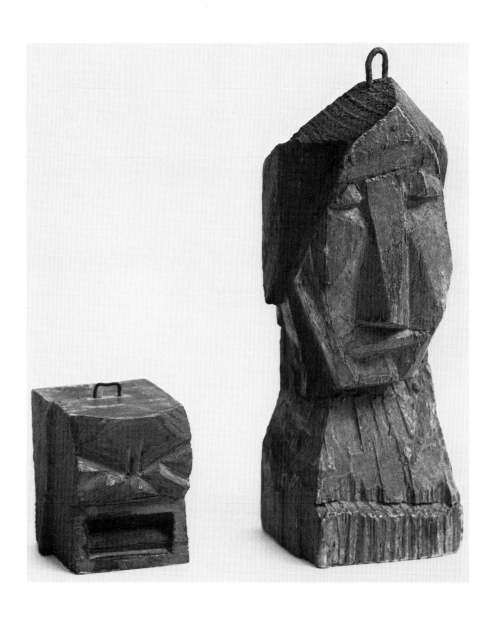

32 Signed in the margin, lower left: *Lyonel Feininger*; numbered, lower center: *1823a*
(53.224)

26 RAINY DAY ON THE BEACH (Regentag am Strande) [State I, proof]. Block cut 1918
Woodcut on thin laid paper; proof, 5⁵/₁₆ x 8⁵/₁₆ in (13.5 x 21.1 cm); sheet, 9⁷/₁₆ x 11⅝ in (24.0 x 29.5 cm)
Signed and inscribed in the margin, lower left: *Lyonel Feininger/Probedruck!/ ♂* [proof]; numbered, lower center: *1826*; inscribed, lower right: *Regentag am Strande*
(53.185)

27 TOWN HALL (WITH AN ASSEMBLY IN FOREGROUND) [Rathaus (mit einer Versammlung in Vordergrund)] Block cut 1918
Woodcut on paper; proof, 4³/₁₆ x 4⅝ in (10.7 x 11.7 cm); sheet, 10¹⁵/₁₆ x 8⅜ in (27.8 x 21.3 cm)
Feininger's work number 1829. Proof occurs on page 1 of a two-page typewritten letter from Lyonel Feininger to Galka Scheyer, signed and dated March 6, 1939.
(53.615)

28 VOLCANO (Vulkan) Block cut 1918

Woodcut on Oriental laid paper; proof, 4¼ x 5¹/₁₆ in (10.8 x 12.8 cm); sheet, 7⅜ x 10¼ in (18.7 x 26.0 cm)
Signed in the margin, lower left: *Lyonel Feininger*; numbered, lower center: *1850a*; inscribed, lower right: *Vulkan*
(53.182)

29 SHIPS AND SUN, 3 (Schiffe und Sonne, 3) Block cut 1918
Woodcut in red ink on yellow tissue paper; proof, 4¾ x 4¹⁵/₁₆ in (12.1 x 12.6 cm); sheet, 11⅝ x 9¹/₁₆ in (29.5 x 23.0 cm)
Feininger's work number 1854. Proof, printed by Andreas Feininger occurs on a one-page holograph letter from Lyonel Feininger to Galka Scheyer, signed and dated December 23, 1922.
(53.228)

30 UNTITLED (Trumpeter and Child) Block cut 1918
Woodcut on paper; proof, 4¹¹/₁₆ x 3½ in (11.9 x 8.9 cm); sheet, 11⅝ x 9 in (29.5 x 22.9 cm)
Feininger's work number 1858. Proof occurs on page 1 of a two-page holograph letter from Lyonel Feininger to Galka Scheyer, signed and dated August 11, 1922.
(53.226)

31 UNTITLED (Trumpeter and Child) Block cut 1918
Woodcut on paper; proof, 4¹¹/₁₆ x 3½ in (11.9 x 8.9 cm); sheet, 11⅝ x 9¹/₁₆ in (29.5 x 23.0 cm)
Feininger's work number 1858. Proof occurs on page 2 of a two-page holograph letter from Lyonel Feininger to Galka Scheyer, signed and dated October 17, 1923.
(53.230)

32 TRAIN ON THE BRIDGE (Zug auf der Brücke) [State I, proof] Block cut 1918
Woodcut on blue tissue paper; proof, 3⅝ x 4⅝ in (9.2 x 11.7 cm); sheet, 4¹⁵/₁₆ x 7½ in (12.5 x 19.1 cm)
Signed in the margin, lower left: *Lyonel Feininger*; numbered, lower center: *1866*; inscribed, lower right: *Probedruck* [Proof]
(53.173)

33 UNTITLED (Promenade) Block cut 1918
Woodcut on blue tissue paper, mounted on heavy paper; proof, 4 x 3⅛ in (10.2 x 7.9 cm); sheet, 7⁷/₁₆ x 4⅞ in (19.0 x 12.4 cm); mount, 9¹³/₁₆ x 7⅞ in (24.9 x 12.5 cm)
Signed in the margin, lower left: *Lyonel Feininger*; numbered, lower center: *1871*
(53.183)

34 YACHT RACE (Yachtrennen)
Block cut 1918
Woodcut on flecked laid paper;
proof, 7¹¹⁄₁₆ x 10½ in (19.5 x 26.4
cm); sheet, 11⅛ x 13⅞ in (28.2 x
35.2 cm)
Signed in the margin, lower left:
Lyonel Feininger; numbered, lower
center: *18103*; inscribed, lower
right: *Yachtrennen*
(53.170)

35 WRECK (Wrack) Block cut
1919
Woodcut on thin, flecked paper;
proof, 4⅝ x 6⁵⁄₁₆ in (11.7 x 16.0 cm);
sheet, 8¹¹⁄₁₆ x 11¹⁄₁₆ in (22.1 x 28.1
cm)
Signed in the margin, lower left:
Lyonel Feininger; numbered, lower
center: *1905*
(53.171)

36 UNTITLED (Three-master with
Flag, 1) Block cut 1919
Woodcut on paper; proof, 3³⁄₁₆ x
3⅝ in (8.1 x 9.2 cm); sheet, 11 x 8⅝
in (28.0 x 21.9 cm)
Feininger's work number 1912a.
Proof occurs on page 1 of a four-
page holograph letter from Lyonel
Feininger to Galka Scheyer, signed
and dated May 3, 1924.
(53.234)

37 UNTITLED (Three-master at
Anchor) Block cut 1919
Woodcut on paper; proof, 2¹¹⁄₁₆ x
2¾ in (6.8 x 6.9 cm); sheet, 11⁹⁄₁₆ x
9 in (29.4 x 22.8 cm)
Feininger's work number 1916a.
Proof occurs on page 2 of a two-page
holograph letter from Lyonel Fein-
inger to Galka Scheyer, signed and
dated January 13, 1924.
(53.611)

38 UNTITLED (Three-master at
Anchor) Block cut 1919
Woodcut on paper; proof, 2¹¹⁄₁₆ x
2¾ in (6.8 x 6.9 cm); sheet, 10¹⁵⁄₁₆ x
8⁹⁄₁₆ in (27.8 x 21.7 cm)
Feininger's work number 1916a.
Proof occurs on page 3 of a four-
page holograph letter from Lyonel
Feininger to Galka Scheyer, signed
and dated May 3, 1924.
(53.236)

39 CALAMITY AT SEA (Unglück
auf See) Block cut 1919
Woodcut on paper; proof, 3⅜ x
2⅞ in (8.6 x 7.4 cm); sheet, 11 x
8⁹⁄₁₆ in (28.0 x 21.7 cm)
Feininger's work number 1918.
Proof occurs on page 1 of a three-
page holograph letter from Lyonel
Feininger to Galka Scheyer, signed
and dated December 23, 1925.
(53.557)

40 UNTITLED (Three Fir Trees)
Block cut 1919
Woodcut on paper; proof, 3⅜ x 3¼
in (8.6 x 8.3 cm); sheet, 10¹⁵⁄₁₆ x 8⁹⁄₁₆
in (27.8 x 21.7 cm)
Feininger's work number 1934a.
Proof occurs on page 4 of a four-
page holograph letter from Lyonel
Feininger to Galka Scheyer, signed
and dated May 3, 1924.
(53.237)

41 UNTITLED (Boats with Reflec-
tions) Block cut 1919
Woodcut on paper; proof, 3⁵⁄₁₆ x
3½ in (8.4 x 8.9 cm); sheet, 10¹⁵⁄₁₆
x 8⁹⁄₁₆ in (27.8 x 21.7 cm)
Feininger's work number 1935.
Proof occurs on page 2 of a four-
page holograph letter from Lyonel
Feininger to Galka Scheyer, signed
and dated May 3, 1924.
(53.235)

42 LITTLE LOCOMOTIVE (Kleine
Lokomotive) Block cut 1919
Woodcut on paper; proof, 2¹⁄₁₆ x
3⅜ in (5.2 x 8.5 cm); sheet, 10¾ x
8¾ in (27.3 x 22.2 cm)
Feininger's work number 1936.
Proof occurs on page 2 of a two-
page typewritten letter from Lyonel
Feininger to Galka Scheyer, signed
and dated November 7, 1938.
(53.613)

43 UNTITLED (Gelmeroda with Sunrise; Abstraction) Block cut 1919
Woodcut on paper; proof, 3⅜ x 2¼ in (8.6 x 5.7 cm); sheet, 11 x 8⅝ in (28.0 x 21.9 cm)
Feininger's work number 1937. Proof occurs on a one-page holograph letter from Lyonel Feininger to Galka Scheyer, signed and dated November 14, 1923.
(53.231)

44 UNTITLED (Gelmeroda with Sunrise; Abstraction) Block cut 1919
Woodcut on paper; proof, 3⅜ x 2¼ in (8.6 x 5.7 cm); sheet, 11 x 8⅝ in (28.0 x 21.9 cm)
Feininger's work number 1937. Proof occurs on a one-page holograph letter from Lyonel Feininger to Galka Scheyer, signed and dated December 30, 1923.
(53.232)

45 UNTITLED (Three-masted Ship) Block cut 1919
Woodcut on thin pink paper, detached from a letter; proof, 2¹³⁄₁₆ x 3¹⁄₁₆ in (7.1 x 7.8 cm); sheet, 4⅛ x 4¼ in (10.5 x 10.8 cm)
Signed and dated in the margin, lower left: *Feininger/1919*. Feinin-

ger's work number 1938. Proof has been detached from a one-page holograph letter from Lyonel Feininger to Galka Scheyer, signed and dated February 2, 1924.
(53.233)

46 UNTITLED (Standup Collars) Block cut 1920
Woodcut on paper; proof, 3¹⁵⁄₁₆ x 3⅝ in (10.0 x 9.2 cm); sheet, 11¹⁄₁₆ x 8½ in (28.1 x 21.6 cm)
Feininger's work number 2019. Proof occurs on page 2 of a two-page holograph letter from Lyonel Feininger to Galka Scheyer, signed and dated April 14, 194(1).
(53.623) Illus. p. 39

47 UNTITLED (Buildings with Crescent Moon) Block cut 1920
Woodcut on paper; proof, 2⅜ x 2⅜ in (6.0 x 6.0 cm); sheet, 11⅛ x 8⅝ in (28.2 x 21.9 cm)
Feininger's work number 2022. Proof occurs on a one-page holograph letter from Lyonel Feininger to Galka Scheyer, signed and dated December 26, 1932.
(53.238)

48 UNTITLED (Buildings with Crescent Moon) Block cut 1920

Crayon on woodcut on paper attached to letter; comp., 2⁷⁄₁₆ x 2⁷⁄₁₆ in (6.2 x 6.2 cm); sheet, 3⁹⁄₁₆ x 3⅝ in (9.1 x 9.2 cm)
Feininger's work number 2022. Composition occurs on page 1 of a two-page typewritten letter from Lyonel Feininger to Galka Scheyer, signed and dated March 5, 1940.
(53.621)

49 SHIPS (With Man on a Pier) [Schiffe] Block cut 1920
Woodcut on paper; proof, 3³⁄₁₆ x 4⅜ in (8.0 x 11.1 cm); sheet, 11 x 8⅝ in (28.0 x 21.9 cm)
Feininger's work number 2024. Proof occurs on page 2 of a two-page holograph letter from Lyonel Feininger to Galka Scheyer, signed and dated August 11, 1922.
(53.227)

50 SHIPS (With Man on a Pier) [Schiffe] Block cut 1920
Woodcut on paper; proof, 3³⁄₁₆ x 4⅜ in (8.0 x 11.1 cm); sheet, 11⅝ x 9¹⁄₁₆ in (29.5 x 23.0 cm)
Feininger's work number 2024. Proof occurs on page 2 of a three-page holograph letter from Lyonel Feininger to Galka Scheyer, signed and dated December 23, 1925.
(53.558)

51 UNTITLED (Windmill and Boat)
Block cut 1920
Woodcut on thin yellow paper;
proof, 2⅞ x 3½ in (7.3 x 8.8 cm);
sheet, 11⅝ x 9¹/₁₆ in (29.5 x 23.0 cm)
Feininger's work number 2027.
Proof occurs on page 1 of a two-page holograph letter from Lyonel Feininger to Galka Scheyer, signed and dated October 17, 1923.
(53.229)

52 UNTITLED (Windmill and Boat)
Block cut 1920
Woodcut on paper; proof, 2⅞ x 3½ in (7.3 x 8.8 cm); sheet, 11⁷/₁₆ x 9 in (29.1 x 22.9 cm)
Feininger's work number 2027.
Proof occurs on page 1 of a two-page holograph letter from Lyonel Feininger to Galka Scheyer, signed and dated January 13, 1924.
(53.610)

53 UNTITLED (Windmill and Boat)
Block cut 1920
Woodcut on paper; proof, 2⅞ x 3½ in (7.3 x 8.8 cm); sheet, 11 x 8½ in (28.0 x 21.6 cm)
Feininger's work number 2027.
Proof occurs on page 1 of a two-page typewritten letter from Lyonel

Feininger to Galka Scheyer, signed and dated July 18, 1942.
(53.626)

54 UNTITLED (Church with Tall Tower) Block cut 1920
Watercolor on woodcut on thin paper; comp., 3¾ x 2⅞ in (9.5 x 7.3 cm); sheet, 4⅜ x 3¾ in (11.1 x 9.5 cm)
Feininger's work number 2029
(53.552)

55 UNTITLED (Gelmeroda Village and Church) Block cut 1920
Woodcut on paper; proof, 4⁵/₁₆ x 2⅞ in (10.9 x 7.3 cm); sheet, 11⅝ x 9¹/₁₆ in (29.5 x 23.0 cm)
Feininger's work number 2030.
Proof occurs on page 3 of a three-page holograph letter from Lyonel Feininger to Galka Scheyer, signed and dated December 23, 1925.
(53.559)

56 UNTITLED (Harbor Entrance with Sailboats) Block cut 1920
Woodcut on Japanese laid paper; proof, 3⅛ x 6⅜ in (8.0 x 16.2 cm); sheet, 6¹¹/₁₆ x 9¾ in (17.0 x 24.8 cm)
Signed in the margin, lower left: Lyonel Feininger; numbered, lower center: 2031
(53.174)

57 C A R N I V A L (K a r n e v a l)
Block cut 1920
Woodcut on thin Japanese paper; proof, 3¾ x 5⁵/₁₆ in (9.5 x 13.5 cm) (irreg.); sheet, 7⅞ x 12 in (19.7 x 30.5 cm)
Signed in the margin, lower left: Lyonel Feininger; numbered, lower center: 2032
(53.223)

58 UNTITLED (Ship with Sun and Moon) Block cut 1921
Woodcut on paper; proof, 2⅜ x 4½ in (6.0 x 11.4 cm); sheet, 10¹⁵/₁₆ x 8½ in (27.8 x 21.6 cm)
Feininger's work number 2102.
Proof occurs on a one-page typewritten letter from Lyonel Feininger to Galka Scheyer, signed and dated December 12, 1938.
(53.614)

59 YELLOW VILLAGE CHURCH, 2 (Gelbe Dorfkirche, 2) Block cut 1921
Woodcut on Oriental laid paper; proof, 6⁷/₁₆ x 8 in (16.4 x 20.3 cm); sheet, 9¹³/₁₆ x 13⁵/₁₆ in (24.9 x 33.8 cm)
Signed in the margin, lower left: Lyonel Feininger; numbered, lower center: 2103
(53.186)

60 UNTITLED (Building with Star) Block cut 1928
Watercolor on woodcut on a letter; comp., 2¹³/₁₆ x 2⅜ in (7.1 x 6.0 cm); sheet, 11 x 8½ in (28.0 x 21.6 cm) Feininger's work number 2801. Composition occurs on a one-page typewritten letter from Lyonel Feininger to Galka Scheyer, signed and dated December 21, 1939.
(53.618)

61 UNTITLED (Trees and Star) Block cut 1928
Watercolor and bronze pigment on woodcut on a letter; comp., 2⁹/₁₆ x 2⁵/₁₆ in (6.5 x 5.9 cm); sheet, 11 x 8⁷/₁₆ in (28.0 x 21.5 cm) Feininger's work number 2803. Composition occurs on page 2 of a two-page typewritten letter from Lyonel Feininger to Galka Scheyer, signed and dated November 13, 1943.
Gift of Mr. and Mrs. Harold P Ullman, 1964
(64.4.8)

62 UNTITLED (Church with Star) Block cut 1928
Woodcut on a letter; proof, 2⅞ x 2⅝ in (7.3 x 6.7 cm); sheet, 10¹⁵/₁₆ x 8⁹/₁₆ in (27.8 x 21.7 cm)

Feininger's work number 2804. Proof occurs on page 2 of a three-page typewritten letter from Lyonel and Julia Feininger to Galka Scheyer, signed and dated February 13, 1931.
(53.240)

63 UNTITLED (Church with Star) Block cut 1928
Woodcut on paper; proof, 2⅞ x 2⅝ in (7.3 x 6.7 cm); sheet, 11⅛ x 8¾ in (28.3 x 22.2 cm) Feininger's work number 2804. Proof occurs on page 2 of a two-page typewritten letter from Lyonel Feininger to Galka Scheyer, signed and dated December 10, 1936.
(53.561)

64 UNTITLED (Church with Star) Block cut 1928
Watercolor on woodcut on paper; comp., 2⅞ x 2⅝ in (7.3 x 6.7 cm); sheet, 10¹⁵/₁₆ x 8⁷/₁₆ in (27.8 x 21.4 cm)
Feininger's work number 2804. Composition occurs on a one-page typewritten letter from Lyonel Feininger to Galka Scheyer, signed and dated January 7, 1945.
(53.631)

65 UNTITLED (Building with Five Stars) Block cut 1928
Watercolor and bronze pigment on woodcut on paper; comp., 2⁷/₁₆ x 2¹¹/₁₆ in (6.2 x 6.8 cm); sheet, 11 x 8⁷/₁₆ in (28.0 x 21.4 cm)
Feininger's work number 2805. Composition occurs on page 1 of a two-page typewritten letter from Lyonel Feininger to Galka Scheyer, signed and dated November 13, 1943.
Gift of Mr. and Mrs. Harold P. Ullman, 1964
(64.4.7)

66 UNTITLED (Three-masted Ship with Star) Block cut 1928
Woodcut on paper; proof, 2⁷/₁₆ x 2½ in (6.2 x 6.4 cm); sheet, 10¹⁵/₁₆ x 8⁹/₁₆ in (27.8 x 21.7 cm)
Feininger's work number 2806. Proof occurs on page 3 of a three-page typewritten letter from Lyonel and Julia Feininger to Galka Scheyer, signed and dated February 13, 1931.
(53.241)

67 UNTITLED (Three-masted Ship with Star) Block cut 1928
Watercolor on woodcut on tissue paper attached to letter; comp.,

$2^7/_{16}$ x $2^9/_{16}$ in (6.2 x 6.5 cm); sheet,
$3^5/_8$ x $3^7/_8$ in (9.2 x 9.8 cm)
Feininger's work number 2806.
Composition is attached to page 2
of a two-page typewritten letter
from Lyonel Feininger to Galka
Scheyer, signed and dated May 9,
1943.
Gift of Mr. and Mrs. Harold P. Ull-
man, 1964
(64.4.6)

68 UNTITLED (Church with Six
Stars) Block cut 1928
Watercolor on woodcut on thin
paper; comp., $2^7/_8$ x $2^9/_{16}$ in (7.3 x
6.5 cm); sheet, 4 x $4^1/_{16}$ in (10.2 x
10.3 cm)
Inscribed in the margin, lower left:
*Galka,/with affectionate greeting!
Papileo.* Feininger's work number
2807
(53.551) Illus. p. 39

69 UNTITLED (Ketch with Star)
Block cut 1930
Woodcut on paper; proof, $2^7/_{16}$ x
$2^7/_8$ in (6.2 x 7.3 cm); sheet, $10^{15}/_{16}$
x $8^9/_{16}$ in (27.8 x 21.7 cm)
Feininger's work number 3001.
Proof occurs on page 1 of a three-
page typewritten letter from Lyo-
nel and Julia Feininger to Galka
Scheyer, signed and dated Febru-

ary 13, 1931.
(53.239)

70 UNTITLED (Ketch with Star)
Block cut 1930
Watercolor on woodcut on paper;
comp., $2^7/_{16}$ x $2^7/_8$ in (6.2 x 7.3 cm);
sheet, $10^{15}/_{16}$ x $8^7/_{16}$ in (27.8 x 21.4
cm)
Feininger's work number 3001.
Composition occurs on page 1 of
a two-page holograph letter from
Lyonel Feininger to Galka Scheyer,
signed and dated April 14, 194(1).
(53.622) Illus. p. 39

71 UNTITLED (Sailing Ship with
Pennant, Deep) Block cut 1933
Woodcut on paper; proof, $2^1/_4$ x $2^1/_2$
in (5.7 x 6.4 cm); sheet, 11 x $8^7/_{16}$ in
(28.0 x 21.4 cm)
Feininger's work number 3301.
Proof occurs on page 1 of a two-
page typewritten letter from Lyo-
nel Feininger to Galka Scheyer,
signed and dated January 9, 1940.
(53.619)

72 UNTITLED (Church with
Houses, Tree and Star, Deep)
Block cut 1933
Watercolor on woodcut on tissue
paper attached to a letter; comp.,
$2^7/_{16}$ x $2^{11}/_{16}$ in (6.2 x 6.8 cm); sheet,

$3^3/_4$ x $3^3/_4$ in (9.5 x 9.5 cm)
Feininger's work number 3303.
Proof occurs on page 1 of a two-
page typewritten letter from Lyo-
nel Feininger to Galka Scheyer,
signed and dated May 9, 1943.
Gift of Mr. and Mrs. Harold P. Ull-
man, 1964
(64.4.5)

73 UNTITLED (Sailing Ship with
Three Stars) Block cut 1933
Woodcut on paper; proof, $2^3/_4$ x
$2^5/_8$ in (7.0 x 6.7 cm); sheet, $11^1/_8$ x
$8^3/_4$ in (28.6 x 22.2 cm)
Feininger's work number 3306.
Proof occurs on page 1 of a two-
page typewritten letter from Lyo-
nel and Julia Feininger to Galka
Scheyer, signed and dated Decem-
ber 10, 1936.
(53.560)

74 UNTITLED (Five Boats and a
Buoy) Block cut 1933
Watercolor and silver pigment on
woodcut on tissue paper attached
to a letter; comp., $2^7/_{16}$ x $2^7/_8$ in (6.2
x 7.3 cm); sheet, $4^{15}/_{16}$ x $4^7/_8$ in (12.6
x 12.4 cm)
Feininger's work number 3310.
Composition occurs on a one-page
typewritten letter from Lyonel Fein-
inger to Galka Scheyer, signed and

dated August 11, 1944.
Gift of Mr. and Mrs. Harold P. Ullman, 1964
(64.4.11)

75 UNTITLED (Still Life with Pitcher) Block cut 1936
Woodcut on paper; proof, $2^5/_8$ x $2^3/_8$ in (6.8 x 6.0 cm); sheet, $10^{15}/_{16}$ x $8^7/_{16}$ in (27.8 x 21.4 cm)
Feininger's work number 3601.
Proof occurs on page 1 of a two-page holograph letter from Lyonel Feininger to Galka Scheyer, signed and dated July 31, 1937.
(53.555)

76 UNTITLED (Two-masted Ship with Star) Block cut 1936
Watercolor on woodcut on paper; comp., $2^7/_{16}$ x $2^{13}/_{16}$ in (6.2 x 6.8 cm); sheet, 11 x $8^5/_8$ in (28.0 x 21.9 cm)
Feininger's work number 3603.
Composition occurs on page 1 of a two-page typewritten letter from Lyonel Feininger to Galka Scheyer, signed and dated November 7, 1938.
(53.612) Illus. p. 39

77 UNTITLED (Two-masted Ship with Star) Block cut 1936
Woodcut on tissue paper attached to a letter; proof, $2^7/_{16}$ x $2^{13}/_{16}$ in (6.2 x 6.8 cm); sheet, 4 x $4^5/_{16}$ in (10.2 x 11.0 cm)
Feininger's work number 3603.
Composition is attached to a one-page typewritten letter from Lyonel Feininger to Galka Scheyer, signed and dated November 12, 1939.
(53.617)

78 UNTITLED (Two-masted Ship with Star) Block cut 1936
Woodcut on paper; proof, $2^7/_{16}$ x $2^{13}/_{16}$ in (6.2 x 6.8 cm); sheet, $10^{15}/_{16}$ x $8^1/_2$ in (27.8 x 21.6 cm)
Feininger's work number 3603.
Proof occurs on a one-page typewritten letter from Lyonel Feininger to Galka Scheyer, signed and dated April 29, 19(40).
Gift of Mr. and Mrs. Harold P. Ullman, 1964
(64.4.4)

79 UNTITLED (Two-masted Ship with Star) Block cut 1936
Watercolor and bronze pigment on woodcut on tissue paper attached to a letter; comp., $2^7/_{16}$ x $2^7/_8$ in (6.2 x 7.3 cm); sheet, $3^3/_{16}$ x $3^{15}/_{16}$ in (8.1 x 10.0 cm)
Feininger's work number 3603.

Composition is attached to page 1 of a two-page typewritten letter from Lyonel Feininger to Galka Scheyer, signed and dated February 29, 1944.
Gift of Mr. and Mrs. Harold P. Ullman, 1964
(64.4.9)

80 UNTITLED (Two-masted Ship) Block cut 1936
Crayon on woodcut on paper; comp., $2^9/_{16}$ x $2^5/_8$ in (6.5 x 6.7 cm); sheet, 11 x $8^1/_2$ in (28.0 x 21.6 cm)
Feininger's work number 3604.
Composition occurs on a one-page typewritten letter from Lyonel Feininger to Galka Scheyer, signed and dated August 3, 1939.
(53.616)

81 UNTITLED (Two-masted Ship) Block cut 1936
Woodcut on paper; proof, $2^9/_{16}$ x $2^1/_2$ in (6.5 x 6.4 cm); sheet, $10^{15}/_{16}$ x $8^7/_{16}$ in (27.8 x 21.4 cm)
Feininger's work number 3604.
Proof occurs on page 1 of a three-page typewritten letter from Lyonel Feininger to Galka Scheyer, signed and dated November 18, 1944.
(53.628)

Dec. 13. 1945

Dearest Little Friend,
 what a sad
little note. — — —
 Galka is very ill,
Galka doesn't listen to music,
nor does she read; only still
she can look a little at pict-
ures; pictures have always made
out her chief happiness, her
great object in living. It is
a great grief, to know Galka
is so ill; we send Galka our
dearest love and wishes for
renewed health. Dear Galka!
 Julia + Papileo

40

83 Feininger Brigantine Block cut 1936 Letter from Lyonel Feininger to Galka Scheyer written on the day of her death.

82 BRIGANTINE Block cut 1936 Woodcut on paper; proof, 2⅛ x 2½ in (5.5 x 6.4 cm); sheet, 10¹⁵⁄₁₆ x 8⁷⁄₁₆ in (27.8 x 21.4 cm) Feininger's work number 3608. Proof occurs on a one-page holograph letter from Lyonel Feininger, signed and dated May 9, 1938. (53.547)

83 BRIGANTINE Block cut 1936 Watercolor and silver pigment on woodcut on paper; comp., 2³⁄₁₆ x 2½ in (5.6 x 6.6 cm); sheet, 11 x 8½ in (28.0 x 21.6 cm) Feininger's work number 3608. Composition occurs on a one-page holograph letter from Lyonel Feininger to Galka Scheyer, signed and dated December 13, 1945. Gift of Mr. and Mrs. Harold P. Ullman, 1964 (64.4.12) Illus. p. 40

84 UNTITLED (Three-masted Ship, 2) Block cut 1937 Watercolor on woodcut on paper; comp., 2⁵⁄₁₆ x 2¾ in (5.9 x 7.0 cm); sheet, 10¹⁵⁄₁₆ x 8⁷⁄₁₆ in (27.8 x 21.4 cm) Feininger's work number 3702a. Composition occurs on page 2 of a two-page typewritten letter from

Lyonel Feininger to Galka Scheyer, signed and dated January 30, 1938. (53.553)

85 UNTITLED (Three-masted Ship, 2) Block cut 1937 Woodcut on paper; proof, 2⁵⁄₁₆ x 2¾ in (5.9 x 7.0 cm); sheet, 11 x 8½ in (28.0 x 21.6 cm) Feininger's work number 3702a. Proof occurs on page 3 of a three-page typewritten letter from Lyonel Feininger to Galka Scheyer, signed and dated November 18, 1944. (53.630)

86 UNTITLED (Two-masted Ship and Sun) Dated in error 1936; Block cut 1937 Woodcut on thin paper; proof, 2¹³⁄₁₆ x 2⅝ in (7.2 x 6.7 cm); sheet, 4¼ x 5¹⁄₁₆ in (10.8 x 12.9 cm) Signed in the margin, lower left: *Lyonel Feininger;* dated, lower right: *1936.* Feininger's work number 3703 (53.550)

87 UNTITLED (Two-masted Ship and Sun) Block cut 1937 Woodcut on paper; proof, 2¹³⁄₁₆ x 2⅝ in (7.2 x 6.7 cm); sheet, 10¹⁵⁄₁₆ x 8⁷⁄₁₆ in (27.8 x 21.4 cm)

Feininger's work number 3703. Proof occurs on page 2 of a two-page holograph letter from Lyonel Feininger to Galka Scheyer, signed and dated July 31, 1937. (53.556)

88 UNTITLED (Two-masted Ship and Sun) Block cut 1937 Watercolor on woodcut on thin paper, detached from a letter; comp., 2¹³⁄₁₆ x 2¾ in (7.2 x 7.0 cm); sheet, 3⅞ x 3¾ in (9.8 x 9.5 cm) Signed in the margin, lower left: *L.F.* Feininger's work number 3703. Composition has been detached from page 2 of a two-page typewritten letter from Lyonel Feininger to Galka Scheyer, signed and dated February 26, 1938. (53.548)

89 UNTITLED (Two-masted Ship and Sun) Block cut 1937 Woodcut on paper; proof, 2¹³⁄₁₆ x 2⅝ in (7.2 x 6.7 cm); sheet, 11 x 8½ in (28.0 x 21.6 cm) Feininger's work number 3703. Proof occurs on a one-page typewritten letter from Lyonel Feininger to Galka Scheyer, signed and dated July 19, 1938. (53.546)

90 UNTITLED (Two-masted Ship and Sun) Block cut 1937
Crayon on woodcut on paper; comp., 2^{13}/$_{16}$ x 2^{13}/$_{16}$ in (7.2 x 7.2 cm); sheet, 10^{15}/$_{16}$ x 8½ in (27.8 x 21.6 cm)
Feininger's work number 3703. Composition occurs on page 2 of a two-page typewritten letter from Lyonel Feininger to Galka Scheyer, signed and dated October 1, 1939. Gift of Mr. and Mrs. Harold P. Ullman, 1964
(64.4.3)

91 UNTITLED (Ships at Harbor Wharf) Block cut 1937
Crayon on woodcut on paper; comp., 2^{11}/$_{16}$ x 3⅛ in (6.8 x 8.0 cm); sheet, 10^{15}/$_{16}$ x 8½ in (27.8 x 21.6 cm)
Feininger's work number 3704. Composition occurs on page 1 of a two-page typewritten letter from Lyonel Feininger to Galka Scheyer, signed and dated October 1, 1939. Gift of Mr. and Mrs. Harold P. Ullman, 1964
(64.4.2) Illus. p. 39

92 UNTITLED (Ships at Harbor Wharf) Block cut 1937
Woodcut on paper; proof, 2^{11}/$_{16}$ x 3⅛ in (6.8 x 8.0 cm); sheet, 11 x 8½ in (28.0 x 21.6 cm)
Feininger's work number 3704. Proof occurs on page 2 of a two-page typewritten letter from Lyonel Feininger to Galka Scheyer, signed and dated January 9, 1940. (53.620)

93 UNTITLED (Still Life with Vase) Block cut 1937
Woodcut on paper; proof, 2^{15}/$_{16}$ x 3⅞ in (7.5 x 9.8 cm); sheet, 10⅞ x 8½ in (27.6 x 21.6 cm)
No work number assigned by Feininger. Proof occurs on page 1 of a two-page typewritten letter from Lyonel Feininger to Galka Scheyer, signed and dated August 23, 1937. (53.549)

94 UNTITLED (Church with Three Stars) Block cut 1938
Watercolor on woodcut on paper; comp., 3^{1}/$_{16}$ x 3^{1}/$_{16}$ in (7.8 x 7.8 cm); sheet, 11 x 8½ in (28.0 x 21.6 cm)
Feininger's work number 3801. Composition occurs on a one-half-page holograph letter from Lyonel Feininger to Galka Scheyer, signed and dated April 5 (1938). (53.545)

95 UNTITLED (Houses with Sun) Block cut 1938?
Woodcut on paper; proof, 2^{11}/$_{16}$ x 3⅛ in (6.8 x 7.9 cm); sheet, 11 x 8½ in (28.0 x 21.6 cm)
No work number assigned by Feininger. Proof occurs on page 1 of a two-page typewritten letter from Lyonel Feininger to Galka Scheyer, signed and dated May 30, 1942. (53.624)

96 UNTITLED (Houses with Sun) Block cut 1938?
Watercolor on woodcut on paper; comp., 2¾ x 3⅛ in (7.0 x 7.9 cm); sheet, 10^{15}/$_{16}$ x 8^{7}/$_{16}$ in (27.8 x 21.4 cm)
No work number assigned by Feininger. Composition occurs on page 1 of a two-page typewritten letter from Lyonel Feininger to Galka Scheyer, signed and dated February 29, 1944.
Gift of Mr. and Mrs. Harold P. Ullman, 1964
(64.4.10)

97 UNTITLED (Houses with Sun) Block cut 1938?
Woodcut on thin laid paper, detached from a letter; proof, 2^{11}/$_{16}$ x 3⅛ in (6.8 x 7.9 cm); sheet, 4^{7}/$_{16}$ x 5½ in (11.6 x 14.0 cm)
No work number assigned by Feininger. Proof has been detached

from page 1 of a two-page typewritten letter from Lyonel Feininger to Galka Scheyer, signed and dated February 26, 1938.
(53.554)

98 UNTITLED (Side-wheeler with Smoke and Sun) Block cut 1940
Woodcut on paper; proof, 2⅝ x 2¹³/₁₆ in (6.2 x 7.2 cm); sheet, 11 x 8½ in (28.0 x 21.6 cm)
No work number assigned by Feininger. Proof occurs on page 2 of a two-page typewritten letter from Lyonel Feininger to Galka Scheyer, signed and dated May 30, 1942.
(53.625) Illus. p. 39

99 UNTITLED (Hudson River Steamer) Block cut 1940
Woodcut on paper; proof, 2⁵/₁₆ x 3¹³/₁₆ in (5.9 x 9.7 cm); sheet, 11 x 8½ in (28.0 x 21.6 cm)
No work number assigned by Feininger. Proof occurs on page 2 of a three-page typewritten letter from Lyonel Feininger to Galka Scheyer, signed and dated November 18, 1944.
(53.629)

SCULPTURE

100 UNTITLED (Head) 1920
Polychromed carved wood sculpture with metal ring attached; 4⅛ x 1⅝ x 1⅝ in (10.5 x 4.1 x 4.1 cm)
Signed and dated on lower surface: *Feininger/ 1920*
(53.188) Illus. p. 31

101 UNTITLED (Head) ca. 1920
Polychromed carved wood sculpture with metal ring attached; 1⅜ x 1⅛ x 1¼ in (3.5 x 2.8 x 3.2 cm)
(53.189) Illus. p. 31

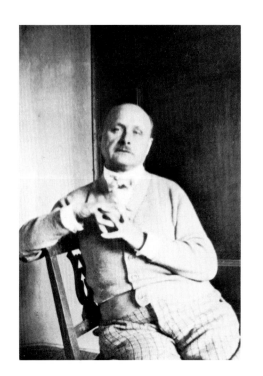

ALEXEI JAWLENSKY
Russian 1864-1941

OILS

102 PINE TREE 1909
Oil on cardboard; 13 x 16⅛ in (32.9 x 41.2 cm)
Signed, lower left: *A.J.*
(53.153) Illus. p. 46

103 WHITE CLOUD (Weisse Wolke) ca. 1909
Oil on linen-finish cardboard; 13 x 17¾ in (32.9 x 44.9 cm)
Signed, lower left: *A.J.*; inscribed, lower right: *Weisse Wolke S167*
(53.136)

104 FLOATING CLOUD
(Schwebende Wolke) 1910
Oil on cardboard; 13 x 16⅛ in (33.0 x 40.9 cm)
Signed, lower left: *A.J.*; inscribed, verso, upper center: *Schwebende Wolke S130*
(53.568)

105 CHILD WITH DOLL (Kind mit Puppe) ca. 1910
Oil on cardboard; 27¼ x 20⅛ in (69.1 x 51.1 cm)
Signed, upper left: *A.J.*; inscribed, upper right: *Kind mit Puppe S* (illegible digits); signed, verso, upper left: *A.J.*
On reverse: oil painting, WOMAN

WITH A NARROW FACE, ca. 1912
(53.86a/b) Illus. p. 59

106 BLONDE 1911
Oil on cardboard; 21 x 19⅜ in (53.3 x 49.2 cm)
Signed, lower left: *A. Jawlensky*
(53.566) Illus. p. 60

107 BLOSSOMING GIRL
(Blühendes Mädchen) ca. 1911
Oil on linen-finish paper, mounted on canvas; 21⅛ x 19⅝ in (53.6 x 49.8 cm)
Signed and inscribed, lower left: *A.J./ Blühendes Mädchen/ S.91*
(53.85) Illus. p. 61

108 HEAD WITH SHAWL ca. 1911
Oil on linen-finish paper, mounted on panel; 20½ x 18⅞ in (52.0 x 47.9 cm)
Signed, lower left: *A.J.*
(53.81)

109 FEATHER HAT: OLGA (Federhut) 1912
Oil on linen-finish paper, mounted on canvas; 21 x 19⅝ in (53.3 x 49.7 cm)
Signed, lower right: *A.J.*; inscribed, lower center: *S.98 Federhut*
(53.80)

110 FIERY HEAD 1912
Oil on linen-finish paper, mounted on canvas; 21⅛ x 19⅝ in (53.7 x 49.8 cm)
Signed, lower left: *A.J.*
(53.83) Illus. p. 62

111 HEAD WITH WHITE OF EYES 1912
Oil on linen-finish cardboard; 20⅞ x 19⅜ in (52.7 x 49.2 cm)
Signed, lower left: *A.J.*
(53.82)

112 MEDITATION 1912
Oil on linen-finish paper, mounted on canvas; 21¼ x 19⅜ in (53.8 x 49.0 cm)
Signed and inscribed, lower left: *A.J./S. . . Trauer* (illegible)
(53.84) Illus. p. 62

113 ORIENTAL CITY (Orient) 1914
Oil on cardboard; 21 x 19½ in (53.3 x 49.4 cm)
Signed, lower left: *A.J.*; inscribed, verso, lower left: *. . . Orient* (partially illegible)
On reverse: oil painting of a landscape, oriented horizontally, n.d.
(53.157) Illus. p. 49

114 BLACK TREE: BORDIGHERA
(Schwarzer Baum: Bordigera) 1914

46

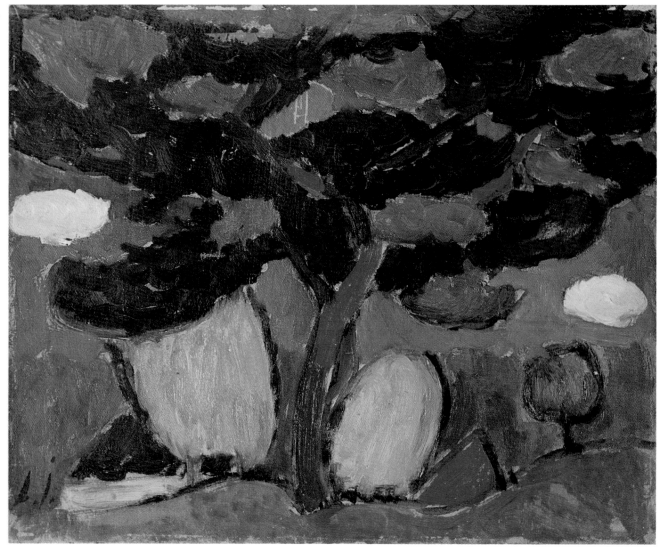

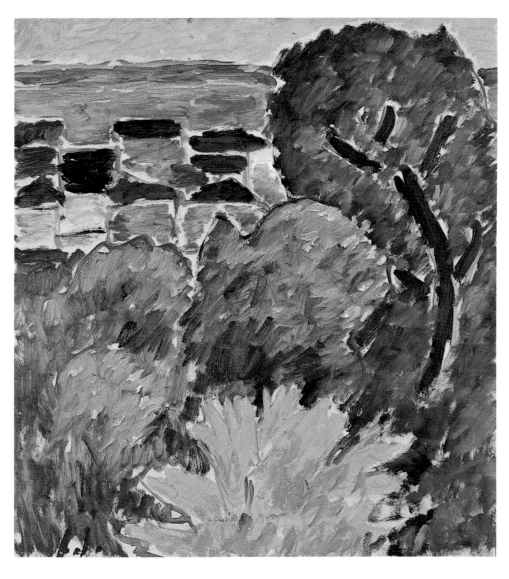

113 Jawlensky Oriental City 1914

117 Jawlensky Variation: Mountain and Lake ca. 1914

116 Jawlensky Variation: Garden Path ca. 1914

119 Jawlensky Variation: Mount Sinai ca. 1915

125 Jawlensky Variation: Spring Evening 1916

126 Jawlensky Variation with Arc ca. 1916

Oil on cardboard; 21 x 19⅜ in (53.2 x 49.2 cm)
Signed, lower left: *A.J.*; inscribed, verso, upper left: *Schwarzer Baum/ Bordigera*
On reverse: oil sketch of an interior, ca. 1914
(53.571) Illus. p. 47

115 CORNFIELD ca. 1914
Oil on linen-finish paper; 10⅝ x 14⅜ in (27.0 x 36.3 cm)
Signed, lower left: *A.J.*; signed, verso, lower left: *A.J.*
On reverse: oil painting VARIATION WITH FENCE, ca. 1914
(53.567)

116 VARIATION: GARDEN PATH ca. 1914
Oil on linen-finish paper; 14⅜ x 10¾ in (36.3 x 27.2 cm)
Signed, lower left: *A.J.*; inscribed, verso, lower left: *S.95* (crossed out); lower center: *Sonntagsgr. 13*
On reverse: oil sketch of a landscape, n.d.
(53.130) Illus. p. 49

117 VARIATION: MOUNTAIN AND LAKE ca. 1914
Oil on linen-finish paper; 15 x 10⅜ in (38.1 x 26.0 cm)

Signed, lower left: *A.J.*; inscribed, verso, lower left: *S2.4* (crossed out); lower right: *Sonntagsgr./ 12*
On reverse: oil painting of a landscape variation
(53.75) Illus. p. 49

118 VARIATION WITH FENCE ca. 1915
Oil on linen-finish paper; 14⅜ x 10¾ in (36.3 x 27.3 cm)
Signed, lower left: *A.J.*; inscribed, verso, lower center: *Sonntagsgr/ 7* (numeral erased); lower left: *S.15* (erased)
(53.110)

119 VARIATION: MOUNT SINAI ca. 1915
Oil on linen-finish paper; 14⅜ x 10¾ in (36.3 x 27.2 cm)
Signed, lower left: *A.J.*; inscribed, verso, lower left: *S.27* (crossed out); lower right: *Sonntagsgr. 5*
On reverse: oil sketch of a landscape, n.d.
(53.98) Illus. p. 49

120 VARIATION: BLUE FAIRY TALE IN BLUE 1915
Oil on canvas, mounted on cardboard; 12½ x 10 in (31.6 x 25.2 cm)
Signed, lower left: *A.J.*
(53.127) Illus. p. 51

121 VARIATION: CHRISTMAS (Weihnachten) ca. 1915
Oil on paper; 14¼ x 10⅝ in (36.0 x 27.0 cm)
Signed, lower left: *A.J.*; inscribed, verso, center: *Liebe ist Geduld A.J.* [Love is patience]; lower right: *Weihnachten/ Sonntagsgr. 6*; lower center: *S.32* (crossed out)
(53.96)

122 VILLAGE ca. 1915
Oil on paper, mounted on cardboard; 13 x 9⅞ in (32.9 x 25.1 cm)
Signed, lower left: *A.J.*
(53.93)

123 YELLOW FLOWER, STILL LIFE II ca. 1915
Oil on canvas, mounted on panel; 13¼ x 11¼ in (33.5 x 28.4 cm)
(53.95)

124 LITTLE HEADS 8: HELENE (8 Kleine Köpfe: Helene) 1916
Oil on paper; 9⅜ x 7 in (23.8 x 17.6 cm)
Signed, lower left: *A.J.*; inscribed, verso, on paper sticker, lower right: *8/ Kleine Köpfe/ Helene*; lower left: *S.10* (crossed out)
(53.144) Illus. p. 66

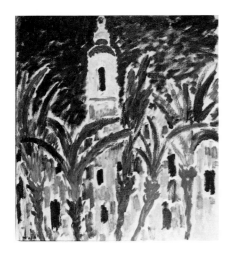
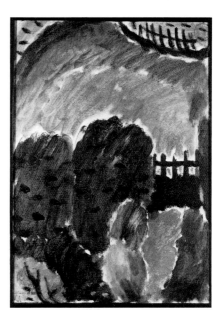
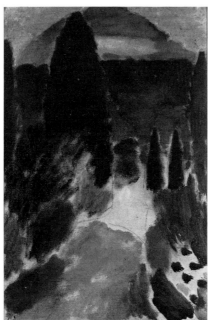

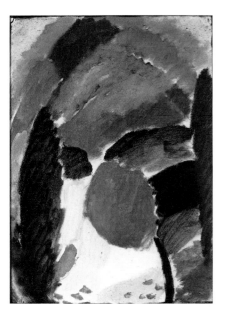
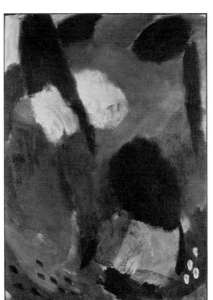
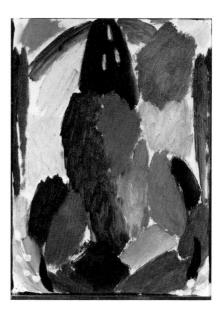

50 **125** VARIATION: SPRING EVE-NING (Frühlingsabend) 1916
Oil on linen-finish paper, mounted on cardboard; 14 x 10⅜ in (35.4 x 26.3 cm)
Signed and dated, lower left: *A. Jawlensky 16*; signed, dated, and inscribed, verso of mount, center: *A. Jawlensky/ 1916/ N.8*
(53.128) Illus. p. 49

126 VARIATION WITH ARC ca. 1916
Oil on paper, mounted on cardboard; 12⅞ x 9⅞ in (32.7 x 25.1 cm)
Signed, lower left: *A.J.*
(53.137) Illus. p. 49

127 VARIATION: ARC OF MOURNING (Trauer Bogen) ca. 1916
Oil on paper; 12⅞ x 10 in (32.7 x 25.2 cm)
Signed, lower left: *A.J.*; inscribed, verso, lower left: *S.36/14* (crossed out); lower right: *S. Prex/ c* (encircled); along lower edge: *Trauer Bogen*
(53.109) Illus. p. 53

128 VARIATION: EASTER ca. 1916
Oil on paper, mounted on card-board; 14¼ x 10⅞ in (36.0 x 27.6 cm)
Signed, lower left: *A.J.*
(53.126)

129 VARIATION: SUMMER BLESSING ca. 1916
Oil on linen-finish paper, mounted on cardboard; 14 x 10¾ in (35.5 x 27.3 cm)
Signed, lower left: *A.J.*; inscribed, verso, center: *Wenn das Licht erlischt in Dir,/ so fällt dunkler Schatten deines/ eigenen Herzens auf Deinen Weg./ Hüte Dich von diesen schrecklichen/ Schatten* [If the light in you is extinguished, then a dark shadow of your own heart falls across your path. Be on guard against these terrible shadows] (entire inscription crossed out); inscribed and signed, lower center: *Grosse Gedanken entstehen/ aus dem Herzen/ A.J.* [Great thoughts arise from the heart]
(53.139) Illus. p. 53

130 VARIATION: SNOW I (Schneevar. I) ca. 1916
Oil on paper; 14¼ x 10⅝ in (36.0 x 27.0 cm)
Signed, lower left: *A.J.*; inscribed, verso, lower left: *S.37* (crossed out); inscribed, lower center: *Schneevar. I/8* (crossed out); *S.Prex/ C* (encircled)
(53.91)

131 VARIATION:ANGER ca.1916
Oil on linen-finish paper; 14¼ x 11⅞ in (36.0 x 30.0 cm)
Signed, lower right: *A.J.*; inscribed, verso, upper right: *getauscht.* [exchanged]; inscribed and signed, center: *Kaum fühlen wir den Zorn / beim Schtreiten, so schtreiten / wir nicht um der Wahrheit / willen, sondern schtreiten für/ Sich/ A.J.* [As soon as we feel the anger while fighting, we no longer fight for the sake of truth but for fighting itself]; inscribed, lower left: *S.29* (crossed out); inscribed, lower center: *8/S. Prex/ B* (encircled)
(53.119)

132 VARIATION: EVENING ca.1916
Oil on linen-finish paper, mounted on cardboard; 14 x 10¼ in (35.4 x 25.9 cm)
Signed, lower right: *A.J.*
(53.141)

133 VARIATION: LARGE PATH ca.1916

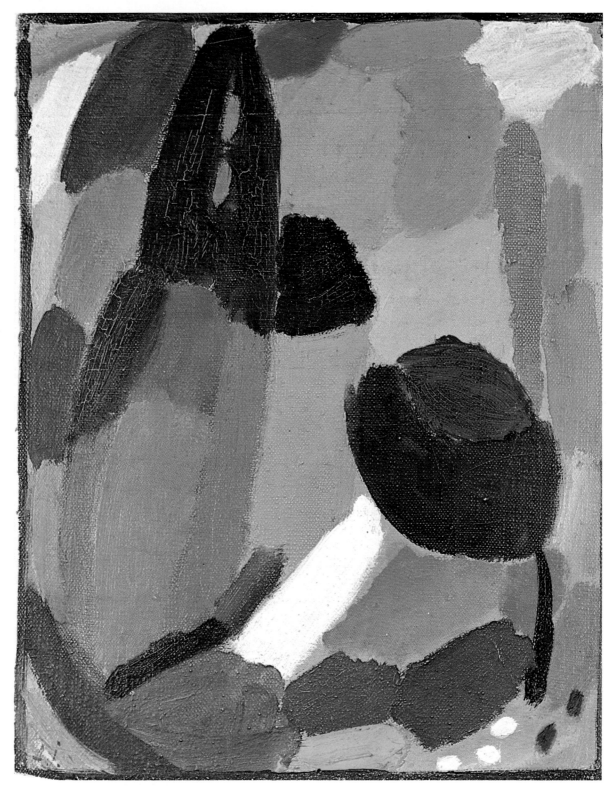

127 Jawlensky Variation: Arc of Mourning ca. 1916

129 Jawlensky Variation: Summer Blessing ca. 1916

133 Jawlensky Variation: Large Path ca. 1916

137 Jawlensky Variation: Wind ca. 1917

141 Jawlensky Variation: Ours 1918

147 Jawlensky Variation: Overture 1919

Oil on linen-finish paper, mounted on cardboard; 21⅝ x 14⅛ in (54.9 x 35.9 cm)
Signed, lower right: A.J.
(53.97) Illus. p. 53

134 THE HUNCHBACK (Der Buckel) 1917
Oil on linen-finish cardboard; 9⅞ x 8⅜ in (24.9 x 21.3 cm)
Signed, lower left: A.J.; inscribed, signed, and dated, verso, upper right: An Die Schauende/ Seele/ A. Jawlensky/ 27. XII. 17. [To the seeing soul/ A. Jawlensky/ December 27, 1917]
(53.150)

135 MYSTIC HEAD, NO. 21: GALKA (M. K., N. 21: Galka) 1917
Oil on cardboard; 15½ x 12 in (39.3 x 30.5 cm)
Signed, lower left: A. Jawlensky; inscribed and dated, verso, upper right: M.K. N.21/ „Galka"/ 1917
(68.1) Illus. p. 67

136 HEADS GROUP I: ANGEL (Köpfe Gr. I: Engel) 1917
Oil on cardboard; 14 x 12 in (35.5 x 30.5 cm)
Inscribed and signed, verso: Lyubit-znachit zhizin/ tovo, kovo lyubish./ Leiben — heisst das

Leben leben,/ dessen den man liebt./ A.J. [To love means to live the life of him whom one loves]; dated, lower center: 1917
(53.569) Illus. p. 68

137 VARIATION: WIND ca. 1917
Oil on linen-finish paper, mounted on cardboard; 14⅛ x 10¾ in (35.9 x 27.3 cm)
Signed, lower left: A.J.
(53.92) Illus. p. 53

138 THE POISON BLOSSOM (Die Giftblüte) 1918
Oil on cardboard, mounted on cardboard; 19¾ x 15⅝ in (50.0 x 39.7 cm)
Signed and dated, lower left: A. Jawlensky 18; inscribed, verso of mount, center: Wenn das Licht erlischt in Dir/ so fällt dunkler Schatten deines/ eigenen Herzens auf Deinen Weg./ Hüte Dich von diesen Schrecklichen/ Schatten./ Kein Licht deines Verstandes kann/ die Dunkelheiten vernichten,/ die aus deines Seele strömen,/ bis nicht aus Deiner seele/ alle eigenliebende Gedanken/ hinaus geschleudert werden./ A.J./ Die „Giftblüte"/ 1918 [If the light in you is extinguished, then a dark shadow of your

own heart falls across your path. Be on guard against these terrible shadows. No light of your understanding can destroy the darknesses which flow out of your soul until all self-loving thoughts have been driven out]
(53.158) Illus. p. 69

139 EARTH 1918
Oil on cardboard; 7¾ x 7¼ in (19.7 x 18.3 cm)
Signed and dated, lower left: A. Jawlensky 18; inscribed, verso: long inscription of three paragraphs in Russian covers entire surface (illegible)
(53.111) Illus. p. 69

140 VARIATION: MOURNING 1918
Oil on linen-finish paper, mounted on cardboard; 14⅜ x 10⅝ in (36.0 x 27.0 cm)
Signed and dated, lower right: A.J. 18
(53.125)

141 VARIATION: OURS (Unsere) 1918
Oil on linen-finish paper, mounted on cardboard; 14⅜ x 10¾ in (36.5 x 27.2 cm)
Signed and dated, lower left: A.J. 18
(53.140) Illus. p. 53

142 VARIATION: MENACING EXPECTATION ca. 1918
Oil on linen-finish paper, mounted on cardboard; 14 x 10¾ in (35.4 x 27.2 cm)
Signed, lower left: *A.J.*
(53.134)

143 VARIATION: TRAGIC ca. 1918
Oil on linen-finish paper, mounted on cardboard; 14⅜ x 10⅝ in (36.3 x 27.0 cm)
Signed, lower left: *A.J.*
(53.133)

144 VARIATION: ATOMS ca. 1918
Oil on linen-finish paper, mounted on cardboard; 14⅜ x 10⅝ in (36.3 x 27.0 cm)
Signed, lower left: *A.J.*
(53.131)

145 FALLEN ANGEL II 1919
Oil on linen-finish paper, mounted on cardboard; 14⅜ x 10¾ in (36.3 x 27.2 cm)
Signed, lower left: *A.J.*
(53.159) Illus. p. 70

146 ASTONISHMENT (Staunen) 1919
Oil on paper, mounted on cardboard; 14¼ x 10⅞ in (36.0 x 27.4 cm)
Inscribed, verso, lower right: *„Staunen"*
(53.570) Illus. p. 70

147 VARIATION: OVERTURE 1919
Oil on linen-finish paper, mounted on cardboard; 14½ x 10¾ in (36.7 x 27.2 cm)
Signed, lower left: *A.J.*
(53.132) Illus. p. 53

148 VARIATION: FALLING 1919
Oil on linen-finish paper, mounted on cardboard; 14⅜ x 10¾ in (36.3 x 27.2 cm)
Signed, lower left: *A.J.*
(53.138)

149 VARIATION: FESTIVAL II 1919
Oil on linen-finish paper, mounted on cardboard; 14⅜ x 10⅝ in (36.3 x 27.0 cm)
Signed, lower left: *A.J.*
(53.94) Illus. p. 54

150 VARIATION: HYMN (Hymne) 1919

Oil on linen-finish paper, mounted on cardboard: 14⅛ x 10¾ in (35.7 x 27.3 cm)
Signed, lower left: *A.J.;* inscribed, verso, lower right: *Hymne. Asc.* [Ascona]
(53.135)

151 VARIATION: LIGHT MIST ca. 1919
Oil on linen-finish paper, mounted on cardboard; 14 x 10 ¾ in (35.6 x 27.3 cm)
Signed, lower left: *A.J.;* inscribed, verso, lower left: *S . . .* (illegible)
(53.113)

152 LAKE MAGGIORE ca. 1919
Oil on paper, mounted on cardboard; 10½ x 15⅛ in (26.6 x 38.2 cm)
(53.129)

153 INCLINED HEAD 1920
Oil on cardboard; 8⅝ x 6⅜ in (21.7 x 16.0 cm)
Signed, lower left: *A.J.*
(53.148)

154 WINTER 1921
Oil on paper, mounted on cardboard; 14 x 10⅜ in (35.6 x 26.3 cm)
Signed, lower left: *A.J.;* inscribed,

signed, and dated, verso, center right: *An meine kleine liebe Galka./ Ihr petschalni A. Jawlensky./ Ostern 1921* [To my deal little Galka/ your poor A. Jawlensky]
(53.154) Illus. p. 72

155 STARLIGHT 1921
Oil on paper, mounted on cardboard; 14⅛ x 10⅝ in (35.7 x 26.8 cm)
Signed, lower left: *A.J.*
(53.156) Illus. p. 72

156 LITTLE HEAD ON WOOD 1921
Oil on panel; 8¼ x 6¼ in (21.0 x 15.9 cm)
Signed, lower left: *A.J.;* inscribed and signed, verso, across upper half: *Meiner Galka/ von A. Jawlensky*
(53.149)

157 LIFE AND DEATH (Leben und Tod) 1923
Oil on cardboard; 16⅞ x 12⅞ in (42.8 x 32.7 cm)
Signed, lower left: *A.J.;* inscribed, signed, and dated, verso, center: *Privatbesitz/ "Leben u. Tod"/ A.v. Jawlensky/ 1923*
(53.78) Illus. p. 73

158 SMALL HEAD 1923
Oil on cardboard; 7⅛ x 5½ in (17.9 x 14.0 cm)
Signed, lower left: *A.J.;* inscribed, verso, across top: *Der Künstler ist/ entweder ein Hoher-/ priester oder ein mehr oder weniger/ geschickter Possenreisser* [The artist is either a high priest or a more or less adept prankster]; inscribed and signed across bottom: *Meiner lieben Galka/ A.v. Jawlensky*
(53.90)

159 FAITH (Glaube) 1924
Oil on cardboard; 7⅛ x 5⅝ in (17.9 x 14.1 cm)
Inscribed, signed, and dated, verso, center: *Der Glaube bestimmt/ den Sinn des Lebens./ Der lieben Galka/ A. Jawlensky/ 15 April 1924* [Faith determines the meaning of life. To the dear Galka]
(53.143)

160 SOUNDS OF WINTER (Winter Lauten [sic]) 1927
Oil on linen-finish cardboard; 16¾ x 12⅞ in (42.4 x 32.5 cm)
Signed, lower left: *A.J.;* inscribed, signed, and dated, verso, upper right: *A. Jawlensky/ „WinterLau-*ten" 1927. Augus(t) / Wiesbaden
(53.105) Illus. p. 75

161 INNER VISIONS 9: RED-BLACK (Inneres Schauen 9: Rot-Schwarz) 1928
Oil on linen-finish cardboard; 16⁹⁄₁₆ x 12¹³⁄₁₆ in (42.1 x 35.1 cm)
Signed, lower left: *A.J.;* inscribed and signed, verso: *Inneres Schauen* ⑨/ *Rot-Schwarz / A.v. Jawlensky*
(53.104) Illus. p. 76

162 SMALL HEAD 1932
Oil on paper; 5⅝ x 4⅝ in (14.1 x 11.6 cm)
Inscribed, signed, and dated, verso: *Meiner lieben Galka in/ der Tüte für Ihren/ Geburtstag 1932, mit/ kranker Hand gemacht,/ aber mit innigem Gefühl./ A. Jawlensky/ April 1932/ Wiesbaden* [To my dear Galka in the bag for her birthday 1932, done with an ill hand, but with ardent feeling]
(53.107)

163 CONTAINED 1932
Oil on cardboard; 7⅛ x 5⅝ in (17.8 x 14.1 cm)
(53.106) Illus. p. 79

164a-j VISIONS: PORTFOLIO GROUP NO. I (Gesichte: Mappe Gr No. I) 1936-37

Portfolio of ten oil paintings, numbered 1 through 10, with hand-lettered title page and list of contents. Each painting is mounted permanently on a cardboard mat (approx. 16½ x 12⅝ in)

a 1936. V, N. 30 (VISONS: I, No. 1) 1936

Oil on linen-finish paper; 10¼ x 7¼ in (25.9 x 18.3 cm)

Signed, lower left: *A.J.;* dated, lower right: *36;* inscribed on mount, lower left: *V 1936;* lower right: *N. 30;* signed and inscribed, verso of mount, center: *A. Jawlensky/ 1936. V./ N. 30*

(54.29.3)

b 1936. VI, N. 7 (VISIONS: I, No. 2) 1936

Oil on linen-finish paper; 9⅞ x 7½ in (25.1 x 19.1 cm)

Signed, lower left: *A.J.;* dated, lower right: *36;* inscribed on mount, lower left: *VI. 1936;* lower right: *N. 7;* signed and inscribed, verso of mount, center: *A. Jawlensky/ 1936. VI./ N.7*

(54.29.5)

c 1936. VI, N. 10 (VISIONS: I, No. 3) 1936

Oil on linen-finish paper; 9⅞ x 7 in (25.1 x 17.6 cm)

Signed, lower left: *A.J.;* dated, lower right: *36;* inscribed on mount, lower left: *VI 1936;* lower right: *N. 10;* signed and inscribed, verso of mount, center: *A. Jawlensky/ 1936. VI./ N10*

(54.29.7)

d 1936. VI, N. 27 (VISIONS: I, No. 4) 1936

Oil on canvas; 8¾ x 6¾ in (22.1 x 17.0 cm)

Signed, lower left: *A.J.;* dated, lower right: *36;* signed and inscribed, verso of mount, center: *A. Jawlensky/ 1936. VI./ N27*

(54.29.9)

e 1936. XI, N. 15 (VISIONS: I, No. 5) 1936

Oil on paper; 10 x 6¾ in (25.2 x 17.1 cm)

Signed, lower left: *A.J.;* dated, lower right: *36;* inscribed on mount, lower left: *XI 1936;* lower right: *N. 1* [5] (cut off by trimmed right edge); signed and inscribed, verso of mount, center: *A. Jawlensky/*

1936 XI./ N.15

(54.29.2) Illus. p. 80

f 1936. XII, N. 5 (VISIONS: I, No. 6) 1936

Oil on paper; 9½ x 7⅝ in (24.1 x 19.4 cm)

Signed, lower left: *A.J.;* dated, lower right: *36;* inscribed on mount, lower left: *XII 1936;* lower right: *N. 5;* signed and inscribed, verso of mount, center: *A. Jawlensky/ 1936. XII./ N5*

(54.29.6)

g 1936. XI, N. 27 (VISIONS: I, No. 7) 1936

Oil on paper; 10 x 6¾ in (25.4 x 17.1 cm)

Signed, lower left: *A.J.;* dated, lower right: *36;* inscribed on mount, lower left: *XI 1936;* lower right: *N. 27;* signed and inscribed, verso of mount, center: *A. Jawlensky/ 1936. XI./ N27*

(54.29.8)

h 1936. XI, N. 18 (VISIONS: I, No. 8) 1936

Oil on paper; 9⅞ x 6¾ in (24.9 x 17.1 cm)

Signed, lower left: *A.J.;* dated, lower

right: *36*; inscribed on mount, lower left: *XI 1936*; lower right: *N. 18*; signed and inscribed, verso of mount, center: *A. Jawlensky/ 1936. XI. N18*
(54.29.1)

i 1937. I, N. 19 (VISIONS: I, No. 9) 1937
Oil on linen-finish paper; 9¾ x 6⅞ in (24.8 x 17.5 cm)
Signed, lower left: *A.J.*; dated, lower right: *37*; inscribed on mount, lower left: *I 1937*; lower right: *N. 19*; signed and inscribed, verso of mount, center: *A. Jawlensky/ 1937. I/ N19*
(54.29.10)

i 1937. I, N. 16 (VISIONS: I, No. 10) 1937
Oil on linen-finish paper; 9¾ x 6⅞ in (24.8 x 17.5 cm)
Signed, lower left: *A.J.*; dated, lower right: *37*; inscribed on mount, lower left: *I 1937*; lower right: *N. 16*; signed and inscribed, verso of mount, center: *A. Jawlensky/ 1937. I./ N16*
(54.29.4)

165 No. 4, I. 1937 (MEDITATION HEAD) 1937
Oil on canvas mounted on cardboard; 11½ x 8¾ in (29.1 x 22.1 cm)
Signed, lower left: *A.J.*; dated, lower right: *37*; inscribed, verso of mount, center: *A. Jawlensky/ I. 1937/ N.4*
(53.152)

WATERCOLORS

166 HEAD WITH OPEN EYES 1920
Watercolor and ink on paper, mounted on cardboard; paper, 8⅝ x 6⅝ in (21.9 x 16.7 cm); mount, 9 x 7 in (22.3 x 17.7 cm)
Signed, lower left: *A.J.*
(53.120) Illus. p. 71

167 LITTLE HEAD, RED-BLACK 1928
Watercolor and gold pigment on paper; 3⅝ x 3½ in (19.2 x 18.7 cm)
Signed, lower left: *A.J.*
(53.147) Illus. p. 77

168 HEAD 1928
Watercolor and ink on paper; image, 2⅞ x 2½ in (7.3 x 6.3 cm); sheet, 8¼ x 6⁷⁄₁₆ in (21.0 x 16.4 cm).
Image occurs on page 1 of a four-page holograph letter from Alexei Jawlensky to Galka Scheyer, signed *A. Jawlensky* and dated by Scheyer 1928.
(53.583)

169 HEAD WITH OPEN EYES and VASE OF FLOWERS 1928
Watercolor and ink on paper; image, 2⅞ x 4⅞ in (7.3 x 12.4 cm); sheet, 8¼ x 6⁷⁄₁₆ in (21.0 x 16.4 cm)
Signed, lower left: *A.J.*
Image occurs on page 4 of a four-page holograph letter from Alexei Jawlensky to Galka Scheyer, signed *A. Jawlensky* and dated by Scheyer 1928.
(53.584)

170 INCLINED HEAD 1928
Watercolor and ink on paper; image, 3⁵⁄₁₆ x 3⅛ in (18.4 x 17.9 cm); sheet, 6¾ x 5⁵⁄₁₆ in (17.2 x 13.5 cm)
Signed, lower left: *A.J.*; dated, lower right: *28*.
Image occurs on page 1 of a four-page folio holograph letter from Alexei Jawlensky to Galka Scheyer signed and dated September 5, 1928.
(53.587)

171 INCLINED HEAD 1928
Watercolor and ink on paper; image, 3⅝ x 3½ in (9.2 x 8.9 cm);

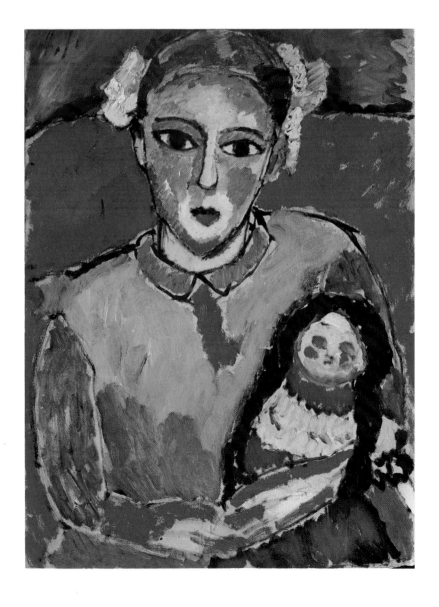

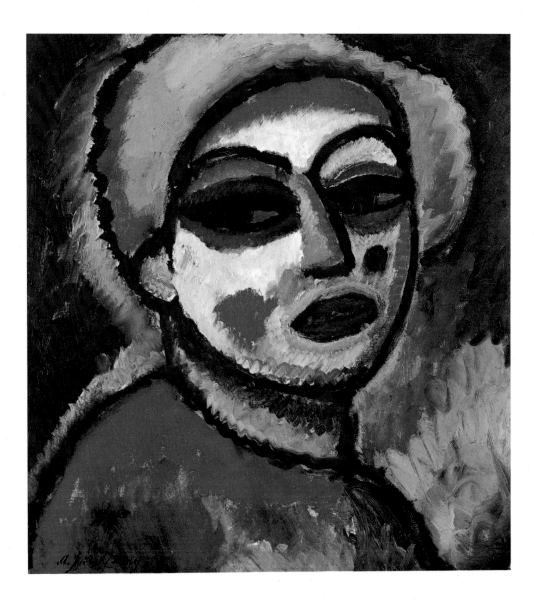

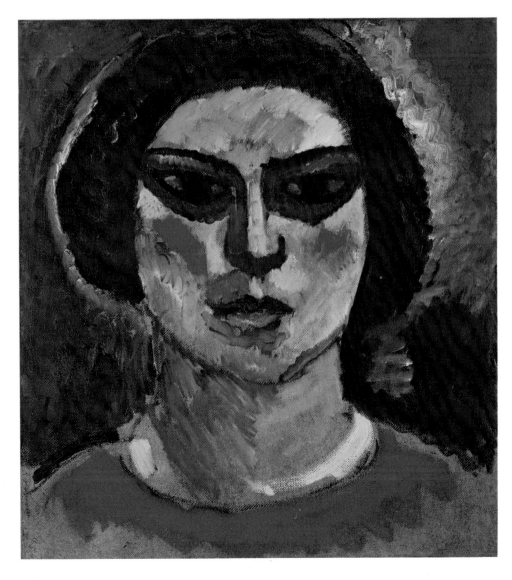

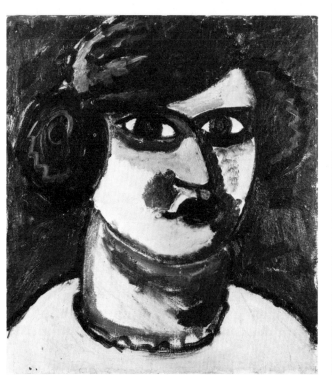

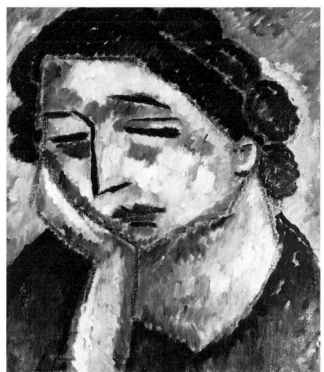

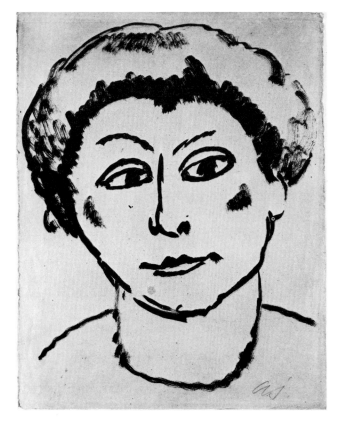

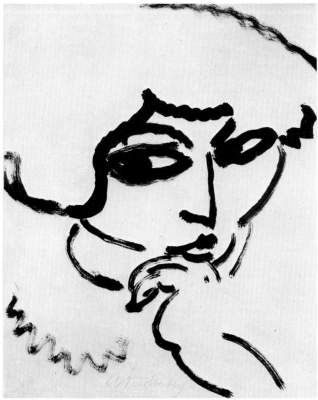

110 Jawlensky Fiery Head 1912 112 Jawlensky Meditation 1912

183 Jawlensky Helene 1912 184 Jawlensky Head 1912

sheet, 6¾ x 5⁵/₁₆ in (17.2 x 13.5 cm)
Signed, lower left: *A.J.*; dated, lower
right: *9.28*
(53.588)

172 THE HUNCHBACK 1928
Watercolor and ink on paper;
image, 4 x 4¹/₁₆ in (10.1 x 10.3 cm);
sheet, 8¼ x 6½ in (21.0 x 16.5 cm)
Signed, lower left: *A.J.*
Image occurs on page 1 of a four-
page holograph letter from Alexei
Jawlensky to Galka Scheyer.
(53.585)

173 COLD, COLD (Kalt, Kalt) 1928
Watercolor and ink on paper;
image, 3¼ x 3⅜ in (8.1 x 8.4 cm);
sheet, 8¼ x 6½ in (21.0 x 16.5 cm)
Letter signed, center of image: *A.
Jawlensky*; inscribed, lower right of
image: *Kalt, Kalt*
Image occurs on page 4 of a four-
page holograph letter from Alexei
Jawlensky to Galka Scheyer.
(53.586)

174 BUST OF A WOMAN 1928
Watercolor and ink on paper; 6¾ x
5⅜ in (17.2 x 13.5 cm)
Signed, lower left: *A.v. Jawlensky*
Image occurs on page 1 of a four-
page folio holograph letter from
Alexei Jawlensky to Galka Scheyer,

signed and dated November 9, 1928.
(53.582)

175 HEAD 1929
Watercolor, ink, and pencil on
paper, detached from a letter;
image, 2¹¹/₁₆ x 2¼ in (6.8 x 5.7 cm);
sheet, 3⁷/₁₆ x 3⁵/₁₆ in (8.8 x 8.4 cm)
Signed, lower left: *A.J.*
Image has been detached from
page 1 of a three-page holograph
letter from Alexei Jawlensky to
Galka Scheyer, signed and dated
February 5, 1929.
(53.145) Illus. p. 77

176 HEAD 1929
Watercolor and ink on paper;
image, 2⁷/₁₆ x 2 in (6.2 x 5.1 cm);
sheet, 6¹¹/₁₆ x 5⁵/₁₆ in (17.0 x 13.5 cm)
Signed, lower left: *A.J.*
Image occurs on page 1 of a four-
page holograph letter from Alexei
Jawlensky to Galka Scheyer, signed
and dated April 2, 1929.
(53.597)

177 HEAD 1929
Watercolor and ink on paper;
image, 3½ x 3⅛ in (8.7 x 7.9 cm);
sheet, 6¾ x 5¼ in (17.1 x 13.3 cm)
Signed, lower left: *A.J.*
Image occurs on a one-page holo-
graph fragment of a letter from

Alexei Jawlensky to Galka Scheyer,
dated by Scheyer 1929.
(53.580)

178 HEAD 1929
Watercolor and ink on paper;
image, 4¼ x 3¾ in (10.8 x 9.4 cm);
sheet, 6¾ x 5¼ in (17.2 x 13.3 cm)
Signed, lower left: *A.J.*
Image occurs on a one-page holo-
graph fragment of a letter from
Alexei Jawlensky to Galka Scheyer,
dated by Scheyer 1929.
(53.598)

DRAWINGS

179 GIRL WITH DOLL ca. 1910
Ink on paper; 18⅜ x 15⅛ in (46.5
x 38.4 cm)
Signed, lower center: *A.J.*
(53.89)

180 HEAD IN REPOSE ca. 1910
Ink on paper; 18⅝ x 15 in (47.3 x
38.1 cm)
Signed, lower center: *A.J.*
(53.101)

181 RECLINING NUDE 1910
Pencil on paper; 8¾ x 11¼ in
(22.2 x 28.6 cm)
Signed, lower right: *A.J.*

63

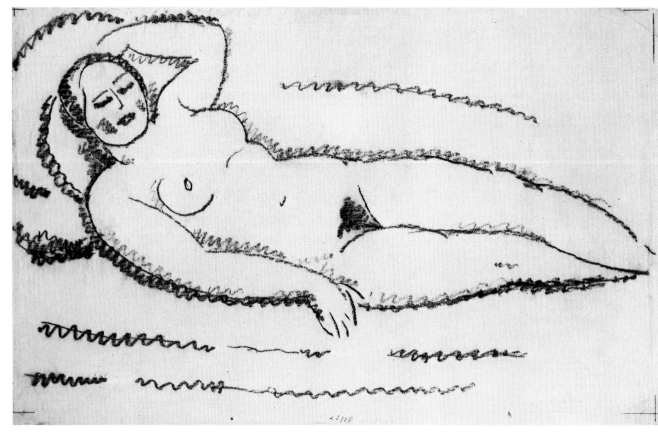

64

Gift of Mr. and Mrs. Harold P.
Ullman, 1964
(64.4.1)

182 HEAD IN PROFILE 1911
Ink on paper; 19¼ x 12⅛ in (48.7 x
30.8 cm)
Signed, lower right: A.J.
(53.88)

183 HELENE 1912
Ink on paper; 18½ x 15⅛ in (47.0 x
38.4 cm)
Signed, lower right: A.J.
(53.100) Illus. p. 62

184 HEAD 1912
Ink on paper; 18⅜ x 15 in (46.7 x
38.1 cm)
Signed, lower center: A. Jawlensky
(53.151) Illus. p. 62

185 HEAD OF A GIRL 1912
Charcoal on paper; 16⅝ x 12⅜ in
(42.2 x 31.3 cm)
Signed and inscribed, lower right:
A. Jawlensky/ an Emmy Scheyer
(53.99)

186 RECLINING NUDE 1912
Pencil on paper; 12¼ x 19⅜ in
(31.2 x 49.2 cm)
Signed, lower left: A.J.
(53.103) Illus. p. 64

187 STANDING NUDE 1912
Pencil on paper; 19⅜ x 12¼ in
(49.2 x 31.2 cm)
Signed, lower right: A. Jawlensky
(53.102)

188 GIRL WITH BUNS ca. 1913
Grease pencil on colored coated
paper; 12¼ x 7¾ in (31.2 x 19.5 cm)
(53.577)

189 PORTRAIT SKETCH
(GALKA SCHEYER) ca. 1917
Pencil on paper; 6⅜ x 4⅜ in (16.2 x
11.0 cm)
Signed, lower left: A. Jawlensky
(53.595)

190 PORTRAIT SKETCH
(GALKA SCHEYER) ca. 1917
Ink on paper; 6⅜ x 4⅜ in (16.1
x 11.0 cm)
Signed, lower left: A. Jawlensky
(53.600) Illus. p. 66

191 PORTRAIT SKETCH
(GALKA SCHEYER) ca. 1917
Pencil on paper; 6⅜ x 4⅜ in (16.1
x 11.0 cm)
Signed, lower left: A.J.
(53.590)

192 PORTRAIT SKETCH
(GALKA SCHEYER) ca. 1917

Pencil on paper; 6⅜ x 4⅜ in (16.1
x 11.0 cm)
Signed, lower left: A.J.
(53.603)

193 PORTRAIT SKETCH
(GALKA SCHEYER) ca. 1917
Pencil on paper; 6⅜ x 4⅜ in (16.1
x 11.0 cm)
Signed, lower right: A.J.
(53.596)

194 SELF-CARICATURE IN PRO-
FILE, HAND IN POCKET ca.1917
Ink on paper; 6⅛ x 4¼ in (15.6 x
10.8 cm)
(53.160)

195 SELF-CARICATURE IN PRO-
FILE, WITH HAT ca.1917
Ink on paper; 6⅛ x 4¼ in (15.6 x
10.8 cm)
(53.161)

196 SELF-CARICATURE IN PRO-
FILE, WALKING ca.1917
Ink on paper; 6⅛ x 4¼ in (15.6 x
10.8 cm)
(53.162)

197 SELF-CARICATURE EN
FACE, WITH TRIANGLE NOSE
ca.1917
Pencil on paper; 4¼ x 3⅜ in (10.8

66

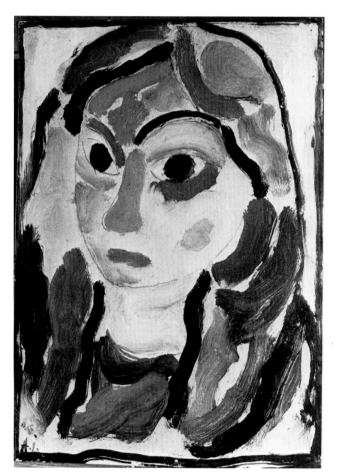

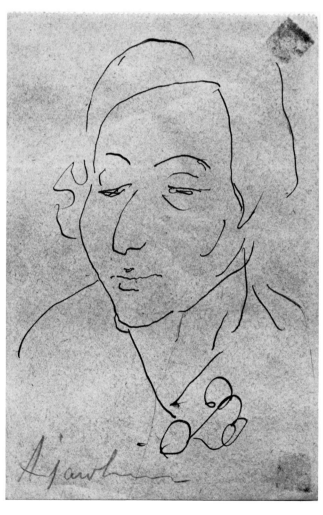

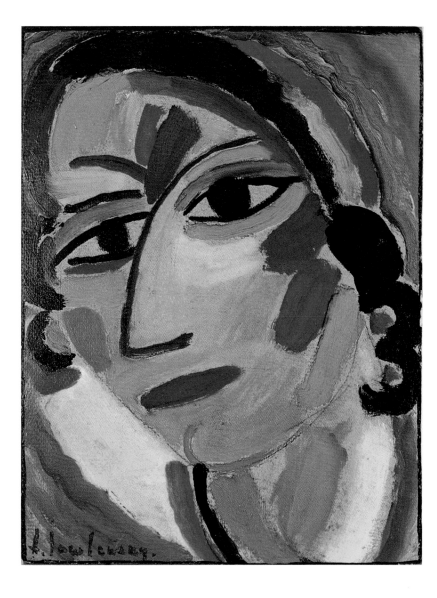

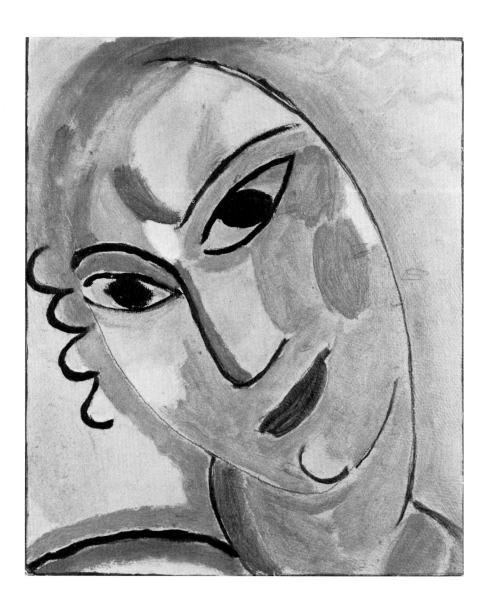

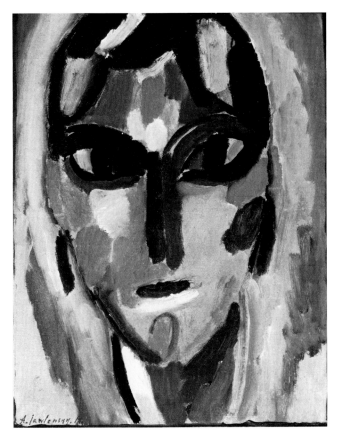

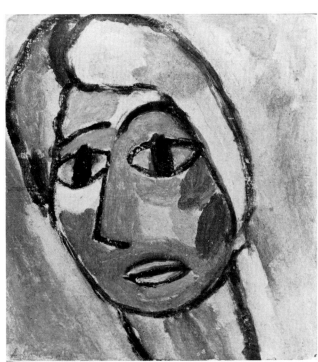

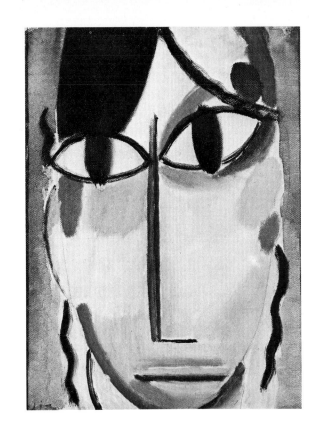
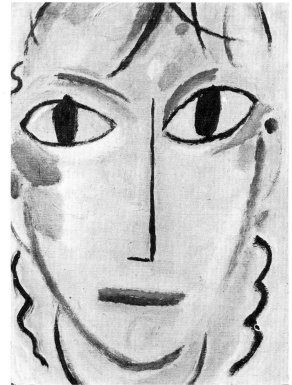

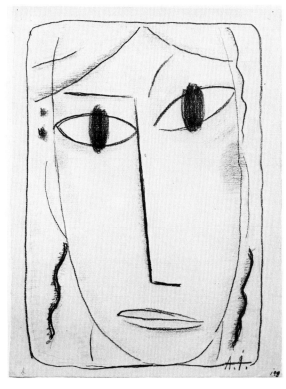
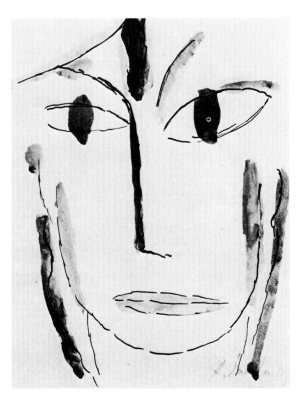

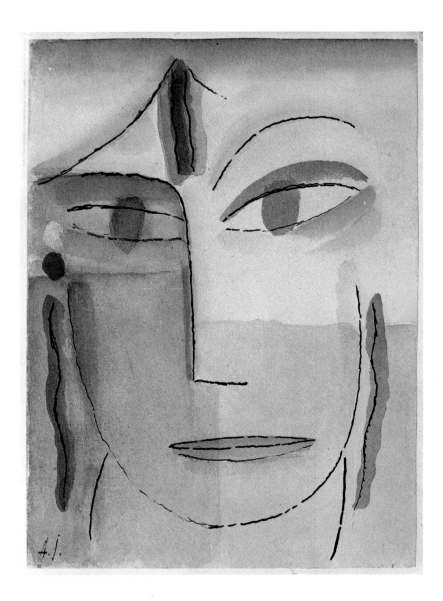

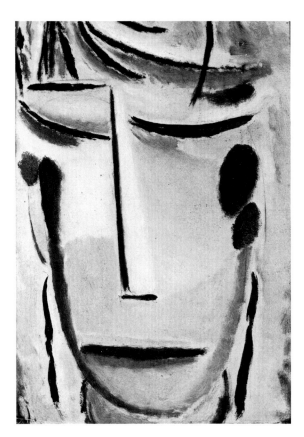
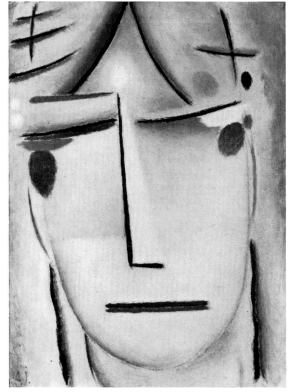

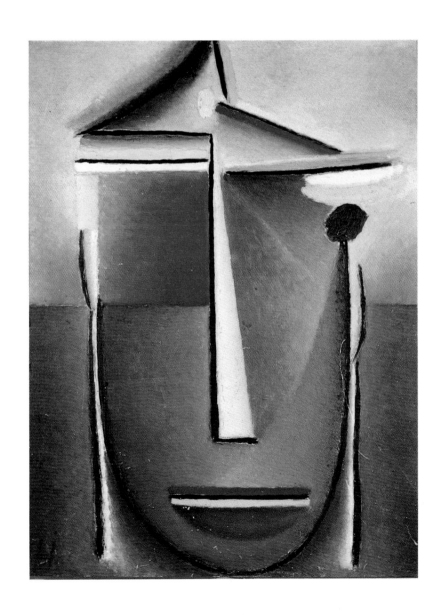

x 8.5 cm)
On reverse: Recto image has been traced through
(53.163)

198 SELF-CARICATURE EN FACE, WITH TRIANGLE NOSE, STANDING IN RAIN ca.1917
Ink on paper; 6⅛ x 4¼ in (15.6 x 10.8 cm)
(53.164)

199 SWINE (Schwein) ca.1917
Pencil on paper; 6¼ x 4¼ in (15.9 x 10.8 cm)
Signed, lower left: *A. Jawlensky;* inscribed, lower right: *Schwein. On reverse:* five caricatures
(53.165a,b)

200 MARIANNE WEREFKIN ca.1917
Pencil on paper; 6⅜ x 4¼ in (16.1 x 10.8 cm)
Signed, lower left: *A.J.;* inscribed, lower center: *Marianne Werefkin. On reverse:* pencil caricature of a head
(53.166a,b)

201 GALKA IN THE BAG (Galka in der Tüte) ca.1917
Crayon and pencil on pink paper;

3¾ x 6⅝ in (9.5 x 16.9 cm)
Inscribed, along lower edge: *Galka in der Tüte*
(53.167)

202 GIRL WITH LONG LASHES, OPEN EYES ca.1918
Pencil on paper; 4¾ x 3⅛ in (12.1 x 8.0 cm)
Signed, lower left: *A.J.*
On reverse: pencil drawing, *Head of a girl with open eyes,* signed, lower right: *A.J.*
(53.593)

203 GIRL WITH OPEN EYES ca. 1918
Pencil on paper; 4⅝ x 2⅞ in (11.7 x 7.3 cm)
Signed, lower left: *A.J.*
(53.592)

204 GIRL WITH LONG LASHES, CLOSED EYES ca.1918
Pencil on paper; 4½ x 3⅜ in (11.4 x 8.6 cm)
Signed, lower left: *A.J.*
(53.601)

205 GIRL WITH OPEN EYES 1918
Pencil on paper; 8⅜ x 4⅞ in (21.3 x 12.4 cm)
Signed, lower left: *A.J.;* lower right:

A.J.
(53.605)

206 HEAD WITH OPEN EYES 1919
Crayon on paper; 10¼ x 8 in (26.1 x 20.3 cm)
Signed, lower right: *A.J.*
(53.112) Illus. p. 70

207 HEAD WITH OPEN EYES 1920
Grease pencil on paper; 4⅝ x 4 in (11.7 x 10.1 cm)
Signed, lower left: *A.J.*
(53.604)

208 HEAD WITH OPEN EYES 1920
Grease pencil on paper; 5⅞ x 5 in (14.9 x 12.7 cm)
(53.578)

209 HEAD WITH OPEN EYES 1920
Pencil on paper; 4⅝ x 4 in (11.7 x 10.1 cm)
Signed, lower left: *A.J.*
(53.599)

210 HEAD WITH OPEN EYES 1920
Grease pencil on tracing paper; 6 x 4⅝ in (15.2 x 11.7 cm)
(53.574)

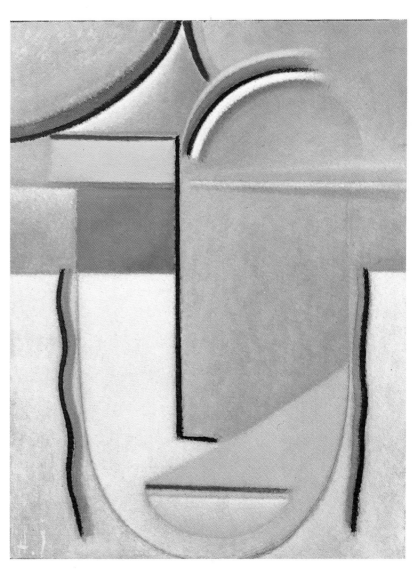

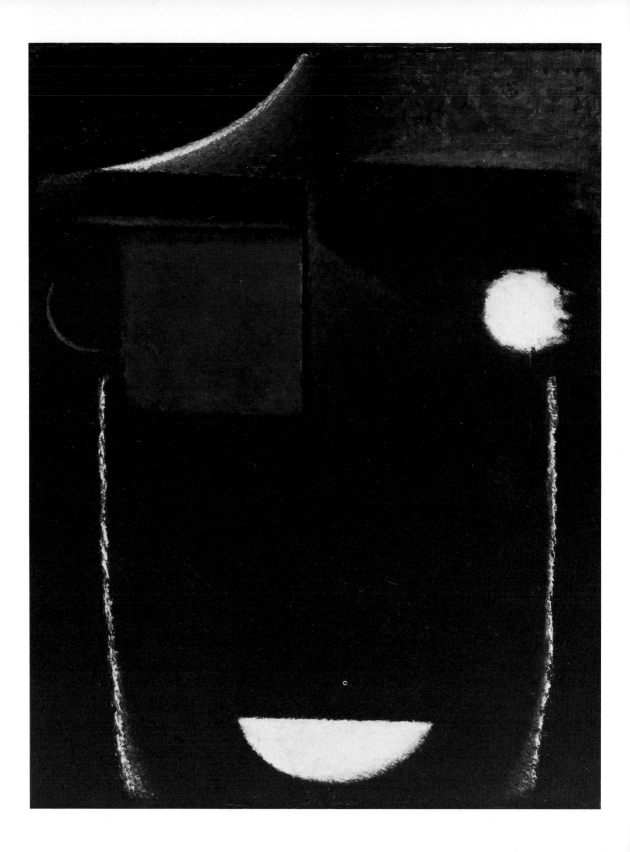

161 Jawlensky Inner Visions 9:
Red-Black 1928

167 Jawlensky Little Head, Red-
Black 1928

175 Jawlensky Head 1929

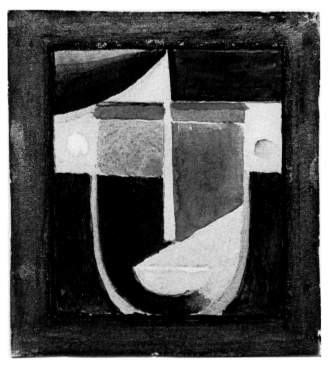

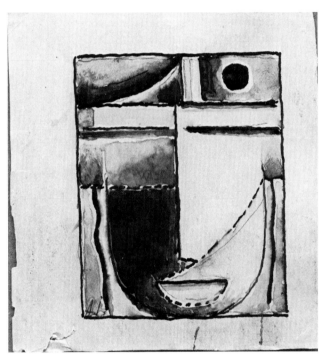

211 HEAD WITH OPEN EYES 1920
Ink on paper; 10⅛ x 7¾ in (25.7 x 19.7 cm)
Signed, lower right: *A. Jawlensky*
(53.124) Illus. p. 70

212 HEAD WITH CLOSED EYES 1920
Grease pencil on paper; 6 x 5⅛ in (15.2 x 13.0 cm)
(53.575)

213 HEAD WITH CLOSED EYES 1920
Colored pencil on paper, mounted on paper; sheet, 3¾ x 2¾ in (9.5 x 7.0 cm); mount, 7⅜ x 3⅝ in (18.7 x 9.2 cm)
Signed, lower left: *A.J.*
(53.591)

214 SAD GALKA. SINGING GALKA. RESTING GALKA (Traurige Galka. Singende Galka. Ruhende Galka) 1921
Pencil on folded paper; 7⅝ x 15½ in (19.4 x 39.4 cm)
Signed, lower left: *A.J.*; inscribed, below left image: *Traurige Galka*; below center image: *Singende Galka*; below right image: *Ruhende Galka*
(53.579) Illus. p. 72

215 HEAD WITH CLOSED EYES: CHRIST HEAD 1921
Pencil on tracing paper; 12⅝ x 9½ in (32.1 x 24.1 cm)
(53.573)

216 INCLINED HEAD (TO LEFT) WITH CLOSED EYES 1921
Pencil on crepe paper, mounted on paper; sheet, 3⅞ x 3⅜ in (9.8 x 8.6 cm); mount, 4⅛ x 3⅝ in (10.5 x 9.2 cm)
Signed, lower left: *A.J.*
(53.594)

217 HEAD WITH CLOSED EYES 1922
Grease pencil on tracing paper; 12¼ x 9⅝ in (31.1 x 24.4 cm)
Signed, lower left: *A.J.*
(53.576)

218 INCLINED HEAD (TO LEFT) WITH CLOSED EYES 1922
Pencil on paper; 12¾ x 9½ in (32.4 x 24.1 cm)
(53.572)

219 INCLINED HEAD 1922
Ink on paper; 9⅞ x 7 in (25.1 x 17.7 cm)
Signed, lower right: *A. Jawlensky*
(53.118)

220 INCLINED HEAD (TO RIGHT) WITH CLOSED EYES 1922
Pencil on paper, mounted on paper; sheet, 3¼ x 3¾ in (8.2 x 9.5 cm); mount, 7⅜ x 5⅝ in (18.7 x 14.3 cm)
Signed, lower left: *A.J.*
(53.602)

221 INCLINED HEAD (TO RIGHT) WITH CLOSED EYES 1922
Pencil and pastel on paper, mounted on cardboard; sheet, 7¾ x 6¼ in (19.6 x 15.9 cm); mount, 14 x 12 in (35.6 x 30.5 cm)
Signed, lower left: *A. Jawlensky*
(53.142)

222 TWO HEADS (Zwei Köpfe) ca.1924
Ink on paper; 7 x 5⅜ in (17.7 x 13.6 cm)
Part of a note from Alexei Jawlensky to Galka Scheyer, n.d.
(53.589)

223 INCLINED HEAD (TO LEFT) WITH CLOSED EYES 1927
Pencil on paper; 11¾ x 10⅛ in (29.9 x 25.7 cm)
Signed, lower right: *A.J.*
(53.117)

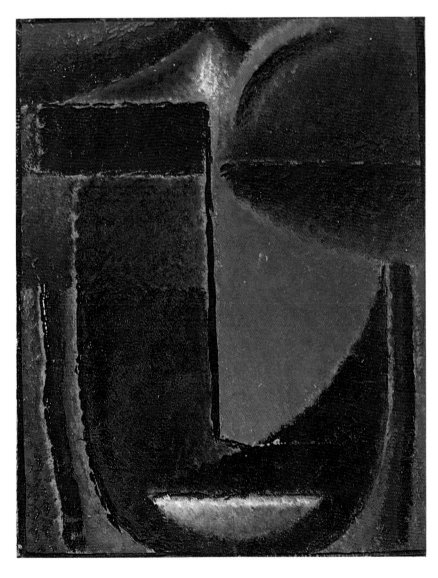

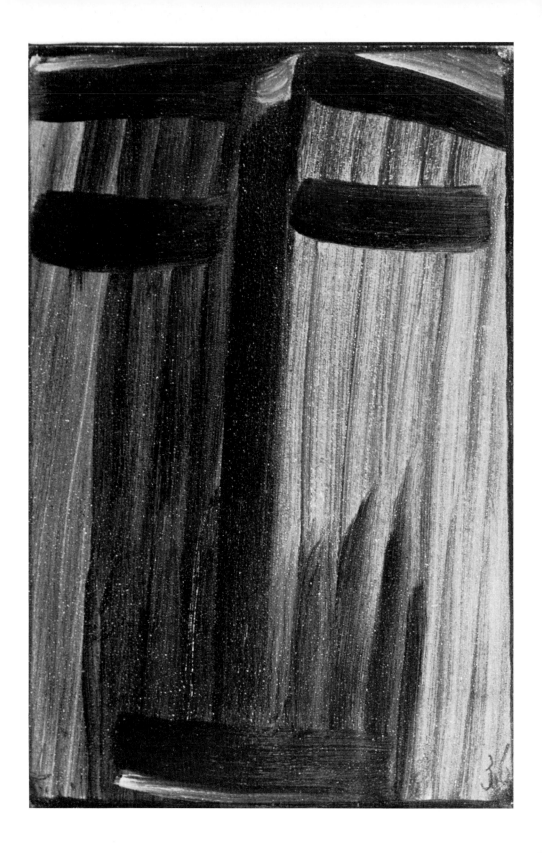

164e Jawlensky Visions: I, No. 5
1936

PRINTS

224 HEAD WITH OPEN EYES
1922
Lithograph with pastel on paper;
16½ x 12 in (41.9 x 30.5 cm)
Signed, lower left: *A. Jawlensky*
(53.76)

225 HEAD WITH CLOSED EYES
1922
Lithograph with pastel on paper;
18⅞ x 12¾ in (47.9 x 32.4 cm)
Signed, lower left: *A. Jawlensky;*
inscribed, lower right: *Meiner lie-
ben Emmy-Galka/ Neu Jahr 1923
A. Jawlensky* [My dear Emmy-
Galka/ New Year 1923]
(53.77)

226 INCLINED HEAD (TO
RIGHT) WITH CLOSED EYES
1922
Lithograph (proof) on paper; 18¼
x 11⅝ in (46.7 x 29.5 cm)
Signed, lower right: *A. Jawlensky*
(53.114)

227 HEAD WITH CLOSED EYES
1922
Lithograph (proof) on paper; 18¼
x 11⅝ in (46.7 x 29.5 cm)
Signed, lower right: *A. Jawlensky;*

inscribed, lower left: *Probedruck*
[Proof]
(53.121)

228 INCLINED HEAD (TO LEFT)
WITH CLOSED EYES 1922
Lithograph (proof) on paper; 18⅛
x 11⅝ in (46.3 x 29.5 cm)
Signed, lower right: *A. Jawlensky;*
inscribed, lower center: *Probedruck*
[Proof]
(53.123)

229 INCLINED HEAD (TO LEFT)
WITH CLOSED EYES 1922
Lithograph (proof) on paper; 12⅝
x 10¹/₁₆ in (32.1 x 25.6 cm)
Signed in the stone, lower left: *A.J.;*
signed on the sheet, lower right:
A. Jawlensky; inscribed, lower left:
Probedruck [Proof]
(53.115)

230 INCLINED HEAD (TO LEFT)
WITH CLOSED EYES 1922
Lithograph (proof) on paper; 11⅝
x 9¼ in (29.5 x 23.5 cm)
Signed in the stone, lower left: *A.J.*
(53.122)

231 HEAD ca.1922
Lithograph (proof) on paper; 18¼
x 11⅝ in (46.2 x 29.5 cm)
(Proof for print 7 from *New Euro-*

*pean Graphics, IV: Italian and
Russian Artists,* Weimar, Bauhaus
1924)
Signed in the stone, lower left: *A.J.;*
on the sheet, lower right: *A. Jaw-
lensky;* inscribed, lower left: *Probe-
druck* [Proof]
(53.116)

232 INCLINED HEAD (TO
RIGHT) WITH CLOSED EYES
1923
Etching on paper; impression, 2½
x 2⅛ in (6.3 x 5.3 cm); sheet, 6½ x
5⅜ in (16.5 x 13.7 cm)
Signed, lower right: *A. Jawlensky*
(53.146)

233 HEAD 1924
Lithograph on paper; 6¹/₁₆ x 4½ in
(15.4 x 11.4 cm)
Signed, lower left: *A.J.*
(53.581)

WASSILY KANDINSKY

Russian 1866-1944

PAINTINGS

234 NO. 151A: SKETCH FOR "DELUGE I" (Skizze zu „Sintflut") 1912
Oil on paper-faced board, mounted on panel; 13⅞ x 19⅛ in (35.1 x 46.6 cm)
Signed and dated, lower left: *Kandinsky 1912*
(64.39) Illus. p. 85

235 WATERCOLOR NO. 77 1923
Watercolor and ink on paper; 18⅝ x 16⅞ in (47.1 x 42.7 cm)
Signed and dated, lower left: ⌀/ 23; inscribed, dated, and signed, verso: *No.77/ 1923/ Der lieben Frau E.E. Scheyer/ in künstlerischer u. menschlicher/ Freundschaft/ Kandinsky/ Weimar/ 31 III 24* [To dear Frau E.E. Scheyer in artistic and humane friendship]
(53.209) Illus. p. 86

236 NO. 398: HEAVY CIRCLES (Schwere Kreise) 1927
Oil on canvas; 22½ x 20½ in (57.2 x 51.9 cm)
Signed and dated, lower left: ⌀/27; signed, inscribed, and dated, verso: ⌀/No. 398/1927/52 x 57/„Schwere Kreise"
(53.216) Illus. p. 87

237 WATERCOLOR NO. 268: LOOSELY BOUND (Mässige Bindung) 1928
Watercolor and ink on paper, mounted on paper; sheet, 12⅝ x 19⅛ in (32.1 x 48.4 cm); mount, 18⅛ x 24⅝ in (46.0 x 62.4 cm)
Signed and dated, lower left: ⌀/ 28; inscribed, verso of mount: *No. 268/ 1928/ „Mässige Bindung"*
(53.214) Illus. p. 88

238 WATERCOLOR NO. 272: FROM COOL DEPTHS (Aus Kühlen Tiefen) 1928
Watercolor on paper, mounted on paper; sheet, 19⅛ x 12¾ in (48.4 x 32.2 cm); mount, 24⅝ x 18¼ in (62.4 x 46.5 cm)
Signed and dated, lower left: ⌀/ 28; inscribed, verso of mount: *No. 272/ 1928/ „Aus Kühlen Tiefen"*
(53.215) Illus. p. 89

239 WATERCOLOR NO. 273: PRESSURE FROM ABOVE (Oberer Druck) 1928
Watercolor and ink on paper, mounted on paper; sheet, 12⅝ x 19⅛ in (32.0 x 48.4 cm); mount, 18⅛ x 24⅝ in (46.0 x 62.4 cm)
Signed and dated, lower left: ⌀/ 28; inscribed, verso of mount: *No. 273/ 1928/ „Oberer Druck"*
(53.213) Illus. p. 90

240 WATERCOLOR NO. 318: SEVERE IN SWEET (Streng in Süss) 1928
Watercolor and ink on paper; 16⅞ x 12¼ in (42.8 x 31.2 cm)
Signed and dated, lower left: ⌀/ 28; inscribed, verso of former mount: *No. 318 / 1928 / „Streng in Süss"*
(53.201) Illus. p. 91

241 NO. 577: DISSIMILAR (Ungleich) 1932
Oil on canvas; 23⅝ x 27⅝ in (60.0 x 70.2 cm)
Signed and dated, lower left: ⌀/ 32; signed, inscribed, and dated, verso: ⌀/ No. 577/ 1932/ „Ungleich"/ 70 x 60
Purchased in 1972 for The Blue Four-Galka Scheyer Collection through funds donated by Mr. and Mrs. Alexander P. Hixon
(72.1) Illus. p. 90

PRINTS

242 UNTITLED VIGNETTE "SPRING," FROM *KLÄNGE* ca. 1911-12
Woodcut on Japanese paper; comp., 4¾ x 3⁹⁄₁₆ in (12.1 x 9.1 cm); sheet, 6½ x 4⅝ in (16.5 x 11.8 cm)

84 Inscribed, on former mount: *Meiner lieben Frau Scheyer/ mit herzlichstem Gruss/ ein Handprobedruck aus „Klänge"/ Kandinsky* [My dear Madame Scheyer, with most heartfelt greetings, a hand proof from "Klänge"]

Hand proof of the vignette for the poem "Spring" in *Klänge*, a book of poems and woodcuts by Kandinsky, 1913

(53.211)

243 UNTITLED COMPOSITION 1922

Lithograph in four colors on German paper; comp., 11 x 9⅝ in (28.0 x 24.5 cm) (irreg.); sheet, 14⅜ x 13½ in (36.5 x 34.3 cm)

Signed and dated in the stone, lower left: *k̲ / 22*; inscribed, verso: *Der lieben Frau E.E. Scheyer/ Kandinsky/ Probedruck aus der Russisch-Italienischen Mappe/ Bauhaus* [Dear Mme. E.E. Scheyer/ Kandinsky/ proof from the Russian-Italian portfolio/ Bauhaus]

Proof of print number eight in the fourth portfolio of Bauhaus prints: *Neue europaeische Graphik: Italienische u. Russische Künstler*, 1924

(53.208) Illus. p. 92

244 "BLUE" LITHOGRAPH 1922

Lithograph in three colors on paper; comp., 8¼ x 5¹³/₁₆ in (21.0 x 14.8 cm) (irreg.); sheet, 12¾ x 10¹⁵/₁₆ in (32.4 x 27.8 cm)

Signed and dated in the stone, lower left: *k̲ / 22*; inscribed in the margin, lower left: *No. 15*; signed, lower right: *Kandinsky*; inscribed and signed on former mount: *Der lieben Frau E.E. Scheyer/ Kandinsky*

(53.202)

245 SMALL WORLDS II (Kleine Welten II) 1922

Lithograph in four colors on medium weight paper; comp., 10¹/₁₆ x 8¾ in (25.6 x 22.2 cm) (irreg.); sheet, 12¹⁵/₁₆ x 11¹/₁₆ in (32.9 x 28.1 cm)

Signed and dated in the stone, lower left: *k̲ / 22*; signed and inscribed in the margin, lower right: *Kandinsky/ Meinem lieben Minister, E.E. Scheyer/ herzlichst Kandinsky* [My dear ambassador, E.E. Scheyer/affectionately Kandinsky]

Print number two in the portfolio *Kleine Welten*, 1922

(53.205)

246 SMALL WORLDS III (Kleine Welten III) 1922

Lithograph in four colors on medium weight paper; comp., 10¹⁵/₁₆ x 9¹/₁₆ in (27.8 x 23.0 cm); sheet, 13⁷/₁₆ x 11 in (34.1 x 28.0 cm)

Signed and dated in the stone, lower left: *k̲ / 22*; signed in the margin, lower right: *Kandinsky*; inscribed and signed, verso: *Der lieben Frau E.E. Scheyer/ Kandinsky/ Probedruck*

Proof for print number three in the portfolio *Kleine Welten*, 1922

(53.207)

247 SMALL WORLDS IV (Kleine Welten IV) 1922

Lithograph in four colors on medium weight paper; comp., 10½ x 10¹/₁₆ in (26.7 x 25.6 cm) (irreg.); sheet, 13⁹/₁₆ x 11⅜ in (34.4 x 28.9 cm)

Signed in the stone, lower left: *k̲* ; signed in the margin, lower right: *Kandinsky*

Print number four in the portfolio *Kleine Welten*, 1922

(53.217)

248 SMALL WORLDS V (Kleine Welten V) 1922

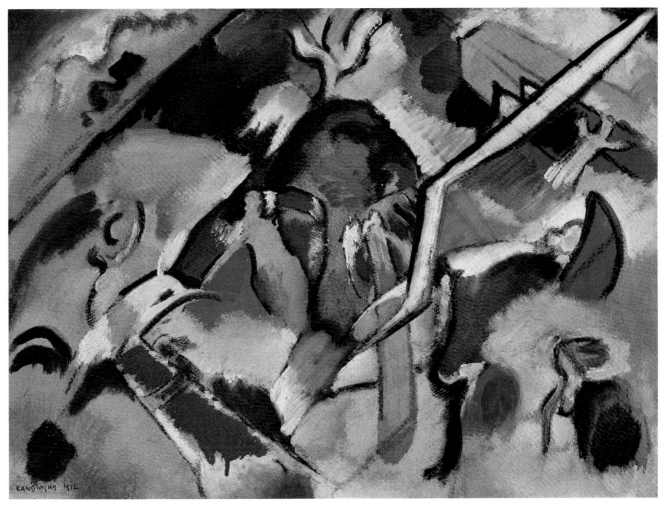

86

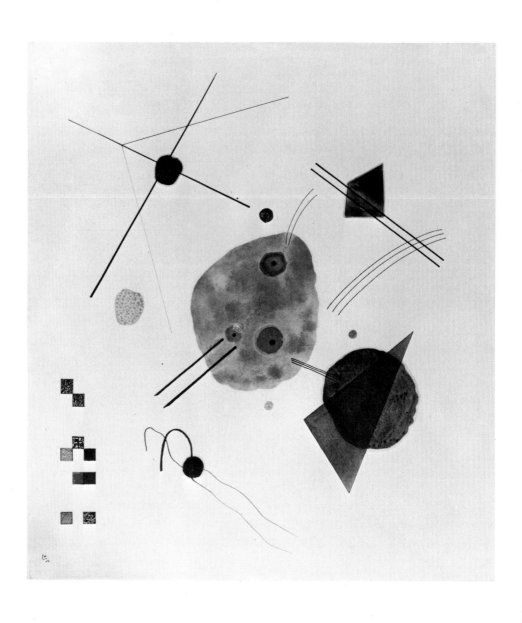

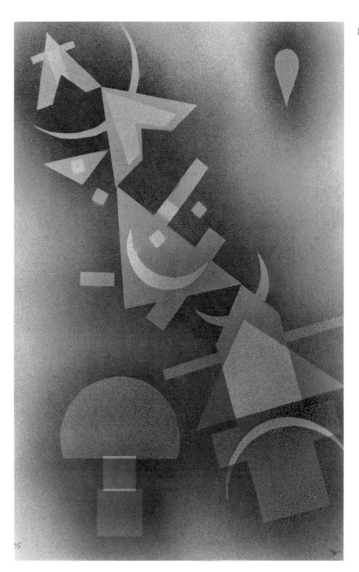

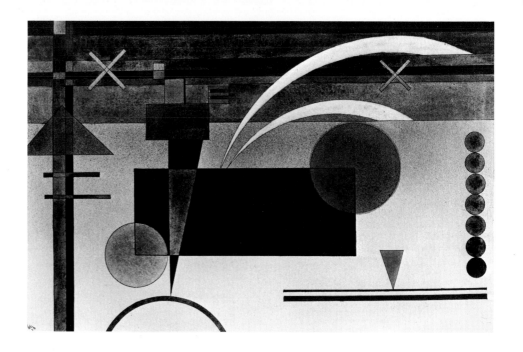

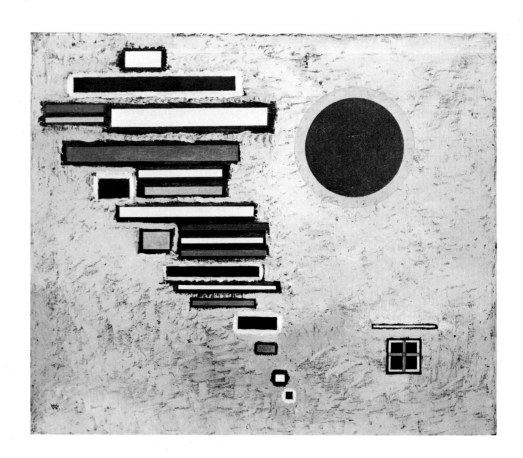

239 Kandinsky Watercolor No. 241 Kandinsky No. 577: Dissimilar 240 Kandinsky Watercolor No.
273: Pressure from Above 1928 1932 318: Severe in Sweet 1928

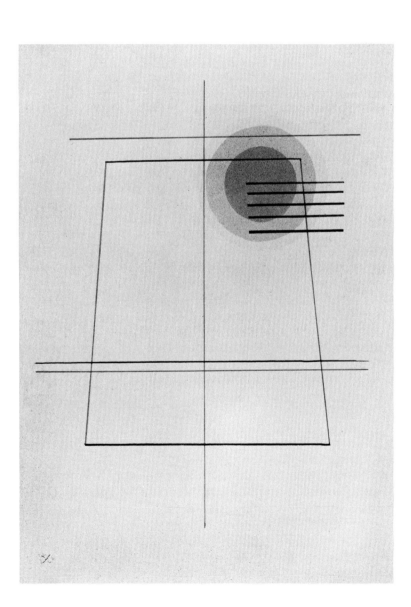

92

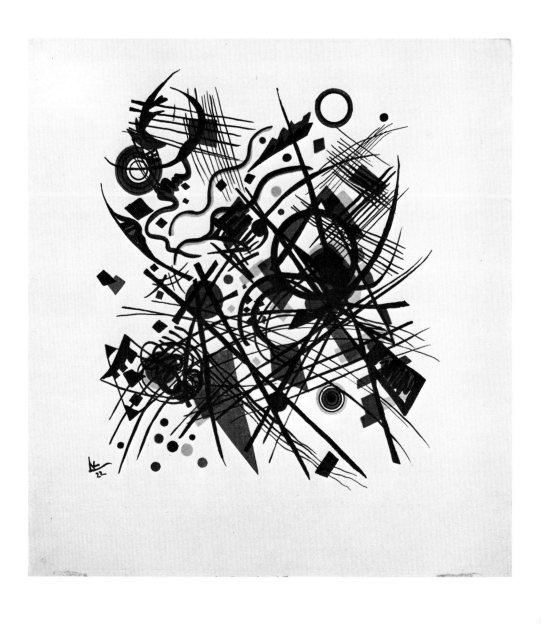

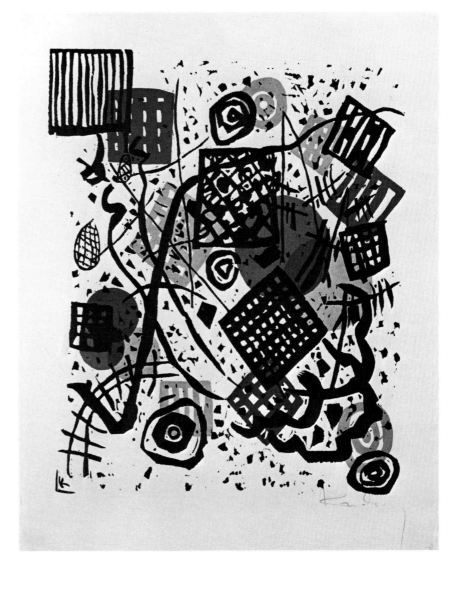

94

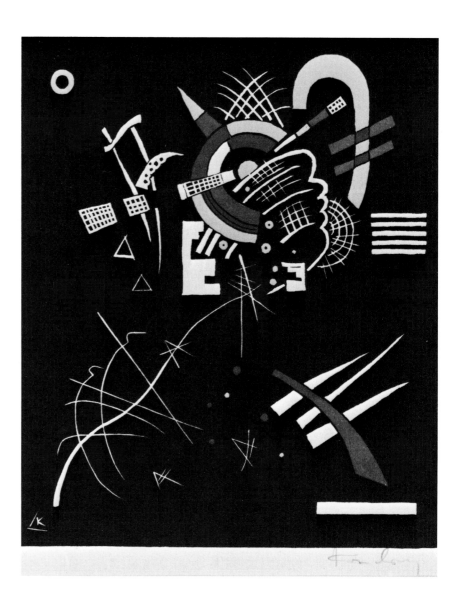

96 Woodcut in four colors, executed as if a lithograph, on medium weight paper; comp., 10¹³/₁₆ x 9⅛ in (27.5 x 23.2 cm) (irreg.); sheet, 13⁵/₁₆ x 10⅞ in (33.8 x 27.6 cm)
Signed in the block, lower left: 𝘬 ; signed in the margin, lower right: *Kandinsky*; inscribed and signed, verso: *Der lieben Frau E.E. Scheyer/ Kandinsky*
Print number five in the portfolio *Kleine Welten,* 1922
(53.203) Illus. p. 93

249 SMALL WORLDS VII (Kleine Welten VII) 1922
Woodcut in three colors, executed as if a lithograph, on medium weight paper; comp., 10¹¹/₁₆ x 9⅛ in (27.2 x 23.2 cm); sheet, 14¹/₁₆ x 11³/₁₆ in (35.7 x 28.4 cm)
Signed, in the block, lower left: 𝘬 ; in the margin, lower right: *Kandinsky*
Print number seven in the portfolio *Kleine Welten,* 1922
(53.218) Illus. p. 94

250 SMALL WORLDS VIII (Kleine Welten VIII) 1922
Woodcut on medium weight paper; comp., 10¾ x 9³/₁₆ in (27.3 x 23.4 cm); sheet, 14⁵/₁₆ x 12¹/₁₆ in (36.4 x 30.7 cm)

Signed, in the block, lower left: 𝘬 ; in the margin, lower right: *Kandinsky*
Print number eight in the portfolio *Kleine Welten,* 1922
(53.220)

251 SMALL WORLDS X (Kleine Welten X) 1922
Etching on heavy paper; impression, 9⁷/₁₆ x 7¹³/₁₆ in (24.0 x 19.8 cm); sheet, 11¹⁵/₁₆ x 10⅝ in (30.3 x 27.0 cm)
Signed, in the plate, lower left: 𝘬 ; in the margin, lower right: *Kandinsky*
Print number ten in the portfolio *Kleine Welten,* 1922
(53.219)

252 SMALL WORLDS XI (Kleine Welten XI) 1922
Etching on heavy paper; impression, 9⅜ x 7¹³/₁₆ in (23.8 x 19.8 cm); sheet, 11⁵/₁₆ x 10⅛ in (28.7 x 25.7 cm)
Signed in the plate, lower left: 𝘬 ; in the margin, lower right: *Kandinsky*; inscribed and signed, verso: *Der lieben Frau E.E. Scheyer/ Kandinsky/ Probedruck*
Proof for print number eleven in the portfolio *Kleine Welten,* 1922
(53.206)

253 VIOLET 1923
Lithograph in four colors on medium weight paper; comp., 11⅝ x 7½ in (29.6 x 19.1 cm) (irreg.); sheet, 13⁹/₁₆ x 10⅝ in (34.5 x 27.0 cm)
Signed and dated in the stone, lower left: 𝘬 / 23; inscribed in the margin, lower left: *No. 10/50;* signed, lower right: *Kandinsky;* inscribed, verso: *Frau E.E. Scheyer*
(53.204) Illus. p. 95

254 UNTITLED ETCHING 1924
Etching on heavy proof paper; impression, 8⁹/₁₆ x 8¼ in (21.8 x 21.0 cm); sheet, 15¹³/₁₆ x 15⅜ in (49.2 x 39.1 cm)
Signed and dated in the plate, lower left: 𝘬 /24; inscribed in the margin, lower left: *No. 22/30;* signed and inscribed, lower right: *Kandinsky/ Meiner verehrten, lieben Frau E.E. Scheyer/ zu Neujahr 1926/ herzlichst/ Kandinsky* [My esteemed, dear Mme. E.E. Scheyer/ at New Year 1926/ affectionately/ Kandinsky]
(53.212)

255 LITHOGRAPH NO. III 1925
Lithograph in two colors on medium weight paper; comp., 10⅜ x 8½ in (26.3 x 21.6 cm); sheet, 19 x 13⅝

in (48.3 x 34.6 cm) Signed and dated in the stone, lower left: ⚔/ 25; inscribed in the margin, lower left: *1925 No. III/ 7/50*; inscribed, signed, and dated, lower right: *Meiner lieben und sehr verehrten/ Frau Galka E. Scheyer/ Kandinsky/ Dessau 15 VII 28* [My dear and very esteemed Mme. Galka E. Scheyer] (53.210)

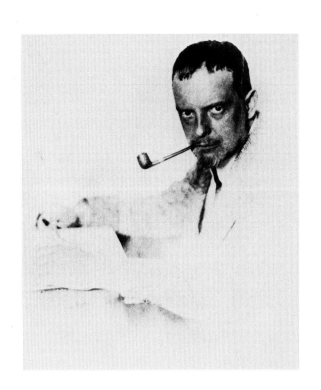

PAUL KLEE

Swiss 1879-1940

PAINTINGS

256 WITH THE BLACK SPOTS
(Mit den schwarzen Tupfen) 1915
Watercolor and ink on Ingres
paper, mounted on paper; comp.,
6¼ x 2⅝ in (15.9 x 6.7 cm); mount,
10⅝ x 5¾ in (26.8 x 14.5 cm)
Signed, lower right: *Klee;* dated and
inscribed on mount, lower center:
1915/251
(53.45) Illus. p. 100

257 REMEMBRANCE-SHEET OF
A CONCEPTION (Erinnerungsblatt
an eine Empfängnis) 1918
Watercolor and ink on thin Fabri-
ano papers, mounted on board;
comp., 10⅛ x 6¾ in (25.7 x 17.0
cm); mount, 10⅝ x 7⅛ in (27.0 x
18.1 cm). Mount has been toned
and reduced to present size.
Signed, upper left: *Klee;* dated and
inscribed on mount, lower left:
1918.75; lower right: *Erinnerungs-
blatt an eine Empfängnis*
(53.26) Illus. p. 100

258 THE TREE OF HOUSES (Der
Häuserbaum) 1918
Watercolor and ink on chalk-
primed gauze on papers, mounted
on painted board; comp., 9¼ x

7⅜ in (23.4 x 18.7 cm); mount, 9⅝
x 7⅞ in (24.5 x 20.0 cm). Margin of
mount has been toned and reduced
to present size.
Signed, upper right: *Klee;* dated
and inscribed on mount, lower left:
1918 Der Häuserbaum
(53.25) Illus. p. 102

259 ORGANIZATION (Einord-
nung) 1918
Watercolor and ink on Japanese
proof paper, mounted on board;
comp., 11¾ x 8⅞ in (29.8 x 22.5
cm); mount, 12⅜ x 9⅝ in (31.4 x
24.4 cm). Mount has been toned
and reduced to present size.
Inscribed on mount, lower left:
Einordnung.
(53.53) Illus. p. 101

260 TUNISIAN GARDENS
(Tunesische Gärten) 1919
Watercolor on Italian Ingres
paper; 9½ x 12¾ in (24.1 x 32.5
cm)
Dated and inscribed, lower left:
1919.31; signed lower right: *Klee*
(53.30) Illus. p. 103

261 NEW HOUSES (Neue Häuser)
1919
Opaque watercolor on Japanese
paper, mounted on board; comp.,

7 x 10⅞ in (17.8 x 27.5 cm); mount,
7½ x 11⅜ in (19.0 x 28.9 cm).
Mount has been toned and reduced
to present size.
Signed, lower left: *Klee;* dated and
inscribed on former portion of
mount, along bottom edge: *1919/
246 Neue Häuser*
(53.29)

262 BLOSSOMS AND GRAINS
(Blüten und Ähren) 1920
Watercolor and ink on French
Ingres paper, mounted on board;
comp., 9⅝ x 6¼ in (24.5 x 15.7 cm);
mount, 11¼ x 7¾ in (28.6 x 19.6
cm)
Signed, lower center: *Klee;* dated
and inscribed on mount, lower left:
1920 89 Blüten und Ähren
(53.54)

263 GARDEN IN RED (Garten in
rot) 1920
Oil, watercolor and ink on papers,
mounted on painted board; comp.,
11¾ x 9¾ in (29.8 x 24.7 cm); mount,
12⅜ x 10⅜ in (31.4 x 26.3 cm).
Margin of mount has been toned
and reduced to present size.
Signed, lower left: *Klee;* dated and
inscribed on mount, lower center:
1920/201 Garten in rot
(53.52) Illus. p. 104

100

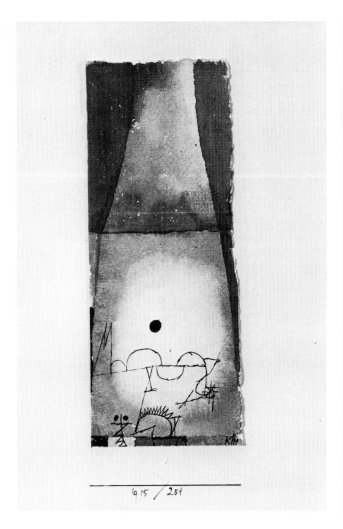

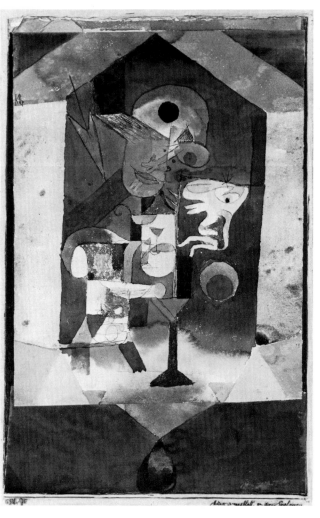

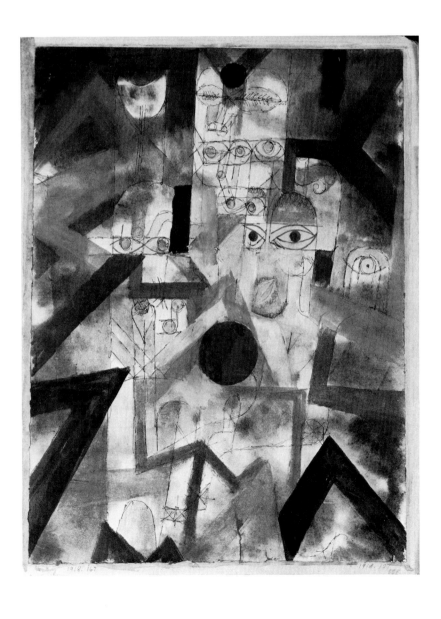

102

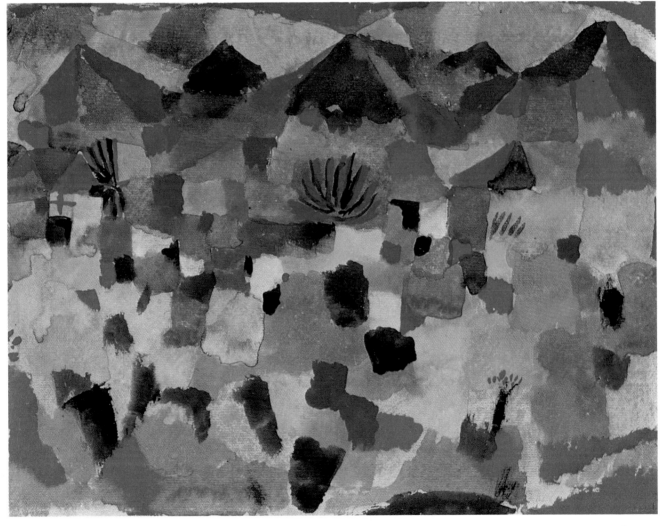

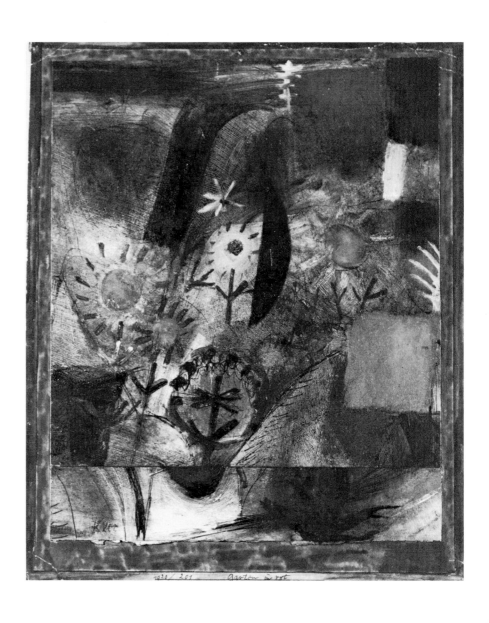

264 THE GATE TO HADES (Das Tor zum Hades) 1921
Watercolor and oil transfer drawing on French Ingres paper, mounted on board; comp., 10¾ x 15½ in (27.3 x 39.2 cm); mount, 12¼ x 16⅞ in (31.1 x 42.9 cm). Mount has been toned and reduced to present size.
Signed, lower right: *Klee*; dated and inscribed on mount, lower center: *1921/29 Das Tor zum Hades*
(53.59) Illus. p. 106

265 TRIPLE PORTRAIT (ONE PERSON SEATED) [Tripelbildnis (eine Person sitzend)] 1921
Watercolor and ink on coarse-grained Fabriano paper, mounted on colored paper, mounted on board; comp., 6⅛ x 5⅞ in (15.5 x 15.0 cm); board mount, 7¾ x 6½ in (19.7 x 16.5 cm). Board mount has been toned and reduced to present size.
Signed, center right: *Klee*; dated and inscribed on board mount, lower left: *1921/32*; lower right: *Tripel Bildnis*
(53.51) Illus. p. 111

266 ROOM PERSPECTIVE RED/GREEN (Zimmerperspektive rot/grün) 1921

Watercolor and pencil on paper, mounted on colored papers, mounted on board; comp., 8⅛ x 10½ in (20.6 x 26.3 cm); board mount, 8½ x 10¾ in (21.6 x 27.3 cm). Board mount has been toned and reduced to present size.
Signed, upper right: *Klee*; dated and inscribed on board mount, lower left: *1921,46 Zimer Perspektive rot/grün*
(53.55) Illus. p. 106

267 BLACK BELL IN THE FOREST (Schwarze Glocke im Wald) 1921
Watercolor and ink on drawing papers, mounted on painted board; comp., 6⅛ x 7¾ in (15.5 x 19.7 cm); mount, 6⅜ x 8 in (16.2 x 20.3 cm). Margin of mount has been toned and reduced to present size.
Signed, upper right: *Klee*; dated and inscribed on mount, lower left: *1921/81*; lower right: *Schwarze Glocke im Wald*
(53.50) Illus. p. 107

268 FLORA OF THE DEAD TOWN (Flora der toten Stadt) 1921
Watercolor and oil transfer drawing on Canson-Ingres papers, mounted on board; comp., 13⅜ x 18⅞ in (34.0 x 48.0 cm); mount,

15 x 20¼ in (38.0 x 51.4 cm)
Signed, center right: *Klee*; dated and inscribed on mount, lower left: *1921/85*; lower center: *Flora der toten Stadt*
(53.34)

269 THE HOLY WOMAN (Die Heilige) 1921
Watercolor and oil transfer on German Ingres paper, mounted on board; comp., 17⅞ x 12¼ in (45.2 x 31.1 cm); mount, 19½ x 13¾ in (49.4 x 34.9 cm). Mount has been toned.
Signed, lower right: *Klee*; dated and inscribed on mount, center left: *1921/107 Die Heilige*; lower right: *Für Emy Scheyer in Freundschaft Weihnachten 1921 Kl* [For Emy Scheyer in friendship Christmas 1921 Klee]
(53.64) Illus. p. 110

270 AQUARIUM GREEN/RED (TWO SMALL SCENES . . .) [Aquarium grün/rot (zwei kleine Scenen . . .)] 1921
Two paintings of watercolor and ink on paper, mounted on metallic-flecked colored paper, mounted on board; comp., 8⅞ x 4¾ in (22.5 x 12.1 cm); board mount, 9½ x 5⅞ in (24.1 x 14.3 cm). Board mount

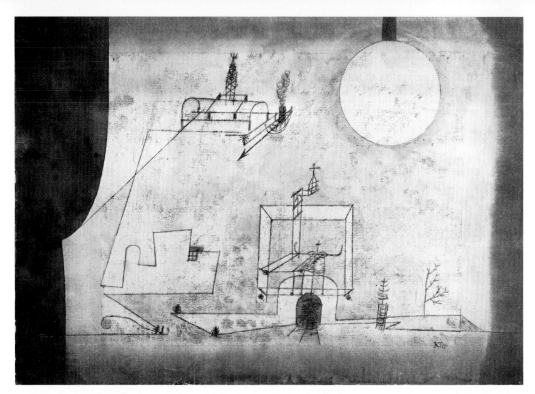

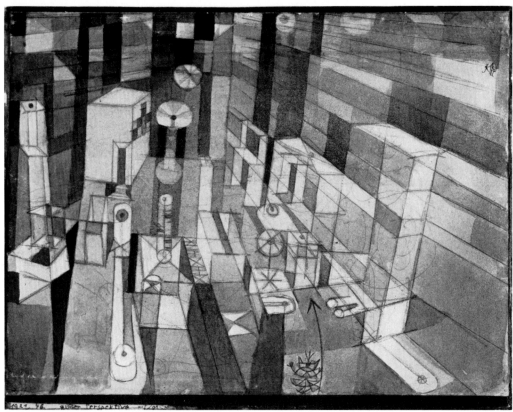

264 Klee The Gate to Hades
1921

266 Klee Room Perspective Red/
Green 1921

267 Klee Black Bell in the Forest
1921

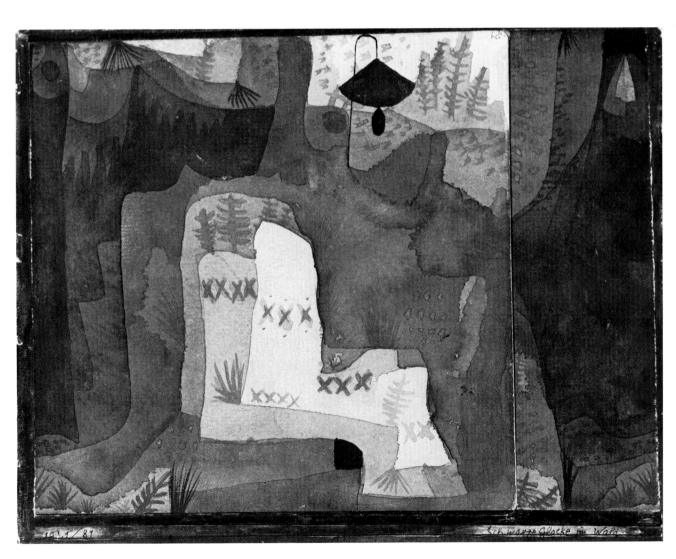

has been toned and reduced to present size.
Signed, lower left: *Klee;* dated and inscribed on mount, lower center: *1921/127 Aquarium grün/rot*
(53.49) Illus. p. 112

271 BARBARIANS' VENUS
(Barbaren-Venus) 1921
Oil, oil transfer, and opaque watercolor on plaster-coated gauze on painted board; comp., 16⅛ x 10½ in (41.0 x 26.7 cm); mount, 17¾ x 12 in (44.9 x 30.5 cm). Margin has been toned.
Signed, center left: *Klee;* dated and inscribed on mount, lower center: *1921/132 Barbaren-Venus*
(53.62) Illus. p. 113

272 MAID OF SAXONY (Mädchen aus Sachsen) 1922
Oil on oil-primed muslin mounted on gold foil, mounted on painted board; comp., 14¼ x 8⅝ in (36.2 x 21.9 cm); board mount, 15⅛ x 9⅜ in (38.4 x 23.7 cm)
Signed, lower center: *Klee;* dated and inscribed on mount, lower left: *1922'/.132;* lower right: *Mädchen aus Sachsen*
(53.63) Illus. p. 114

273 ACTOR AS A WOMAN
(Schauspieler als Frau) 1923
Watercolor and ink on German Ingres papers mounted on painted board; comp., 10⅛ x 9 in (25.7 x 22.9 cm); mount, 11⅛ x 10 in (28.2 x 25.5 cm). Mount has been reduced to present size.
Signed, dated, and inscribed, lower right: *Klee/ 1923 4/12;* lower center: *1923/ / /49 Schauspieler als Frau;* on mount, lower left: *Fur Emy Scheyer Juni 1923 K*
(53.36) Illus. p. 115

274 IDOL FOR HOUSE CATS
(Götzenbild für Hauskatzen) 1924
Oil transfer, watercolor, and lace collage on chalk-primed muslin, mounted on painted board; comp., 13⅞ x 18⅜ in (35.1 x 46.5 cm); mount, 15⅜ x 19¾ in (39.0 x 50.1 cm)
Signed, lower right: *Klee;* dated and inscribed on mount, lower left: *VI;* lower center: *1924 14 Götzen Bild für Haus Katzen*
(53.57) Illus. p. 116

275 SWAMP WATER-SPRITE
(Sumpf Wassernixe) 1924
Watercolor and oil transfer on

German Ingres paper, mounted on board; comp., 11¾ x 18¼ in (29.7 x 46.3 cm); mount, 14⅛ x 20⅝ in (35.9 x 52.4 cm). Mount has been toned.
Signed, upper left: *Klee;* inscribed on mount, lower left: *V:* dated and inscribed, lower center: *1924.6.7 Sumpf wasser Nixe*
(53.31)

276 ARABIAN BRIDE (Arabische Braut) 1924
Watercolor and crayon on notepapers, mounted on painted board; comp., 13⅜ x 6½ in (34.0 x 16.5 cm) (irreg.); mount, 14⅛ x 6⅞ in (36.0 x 17.5 cm)
Signed, lower left: *Klee;* dated and inscribed on mount, lower left: *1924 151;* inscribed, lower right: *Arabische Braut*
(53.24) Illus. p. 117

277 PLANT SEEDS (Pflanzensamen) 1927
Watercolor and ink on German Ingres paper, mounted on painted board; comp., 12⅞ x 18⅜ in (32.7 x 46.7 cm); mount, 19¼ x 25⅜ in (48.9 x 64.4 cm)
Signed, lower left: *Klee;* dated and

inscribed on mount, lower left: *VII 1927 Ue 8;* inscribed, lower right: *Pflanzen Samen*
(53.20) Illus. p. 118

278 REFUGE (Zuflucht) 1930
Oil, opaque and transparent watercolor on plaster-coated gauze, on paper-faced board, in wood frame; 21⅜ x 13⅞ in (54.3 x 35.2 cm); artist's frame, 22⅜ x 15 x 1⅜ in (56.8 x 38.1 x 3.5 cm)
Signed, lower right: *Klee;* dated and inscribed, verso, across center: *1930. L1 „Zuflucht" Klee / Technik / 1 mit 5 grund / 1, Pappe / 2, weisse Öl — Lackfarbe / Solange 2, noch Klebrig: 3, Gaze und / Gipsgrund / 4, Aquarellfarbe rot brun als Unterton / 5, Tempera (Neisch) Zinkweiss mit Leinzusatz / 6, Feine Zeichnung und gestrichelte malerei mit aquarellfarbe / 7, Mit Ölgemalde firnis (terpentinverschiät)* [unclear] *leicht befestigt / 8, mit Zinkweiss-Ölfarbe teilweise aufgehellt / 9, mit Öl graublau gedeckt / mit Öl Krapplack getuscht* [Execution: 1, cardboard / 2, white oil — enamel pigment / when 2 has become tacky gauze and / plaster / 4, watercolored red-brown as undertone / 5, tempera (brand name?) zinc white with linseed mixture / 6, delicate drawing and brush-stroked hatching with watercolor / 7, lightly anchored with oil-painting varnish (turpentine-thinner) / 8, partly illuminated with zinc white oilpaint / 9, covered with oil gray-blue / washed with oil madder lake]
(53.65) Illus. p. 119

279 MAIDEN'S TERROR (Mädchenschreck) 1930
Impastoed opaque watercolor on paper, mounted on board; comp., 15¾ x 19⅞ in (40.0 x 50.4 cm); mount, 16¼ x 20½ in (41.2 x 52.0 cm). Mount has been toned and reduced to present size.
Signed, lower center: *Klee;* inscribed on former portion of mount, lower left: *VIII;* dated and inscribed, lower right: *1930.0.8 Mädchenschreck*
(53.21)

280 HEAD, PSYCHO-GENETIC (Kopf, psycho-genetisch) 1931
Watercolor on paper; 13⅛ x 8¼ in (33.3 x 21.0 cm)
Signed, lower right: *Klee;* dated and inscribed on former mount, lower center: *1931. p.2 Kopf, psychogenetisch*
(53.27)

281 BEARDED MASK (Bärtige Maske) 1931
Watercolor on paper, 9½ x 13⅛ in (18.7 x 33.3 cm)
Signed, lower right: *Klee;* dated and inscribed on former mount, along lower edge: *1931 p.6 bärtige Maske*
On reverse: pencil drawing of a head
(53.35) Illus. p. 120

282 MEMORY OF A BIRD (Erinnerung an einen Vogel) 1932
Watercolor on French Ingres paper; 12¼ x 19 in (31.1 x 48.2 cm)
Signed, lower right: *Klee;* dated and inscribed on former mount, lower left: *1932.7 Erinnerung an einen Vogel*
On reverse: pencil drawing of a head (incomplete) and shoulders, reduced from a larger sheet
(53.33) Illus. p. 125

283 BOY AT TABLE (Knabe am Tisch) 1932
Watercolor and ink on Italian Ingres paper; 11⅞ x 18⅞ in (30.2 x 47.9 cm)

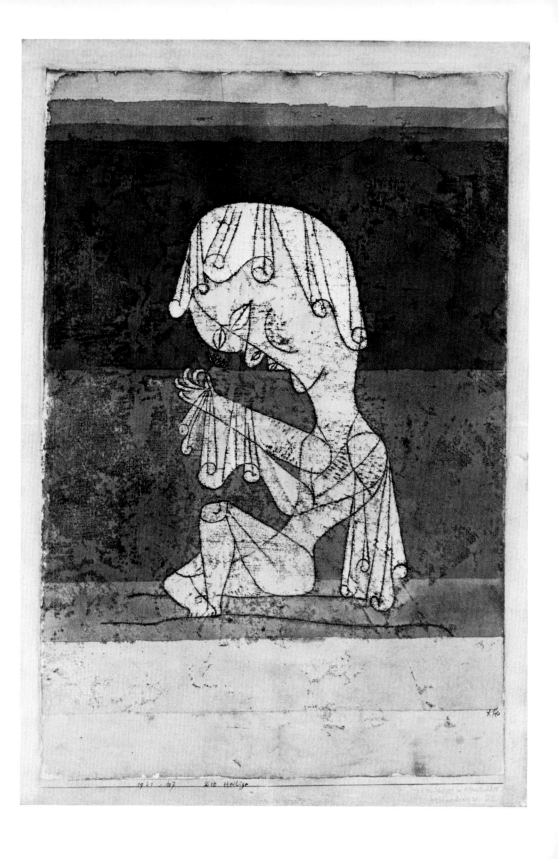

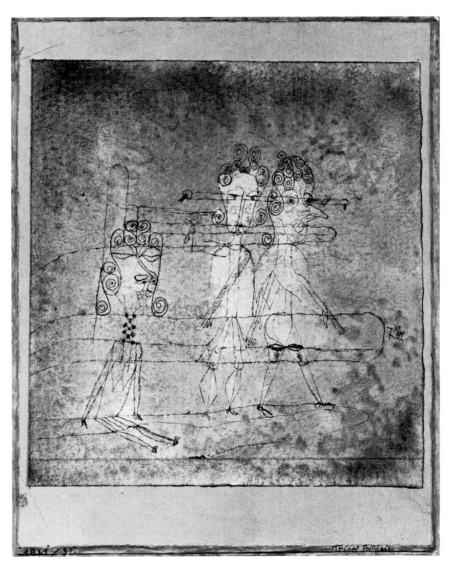

112

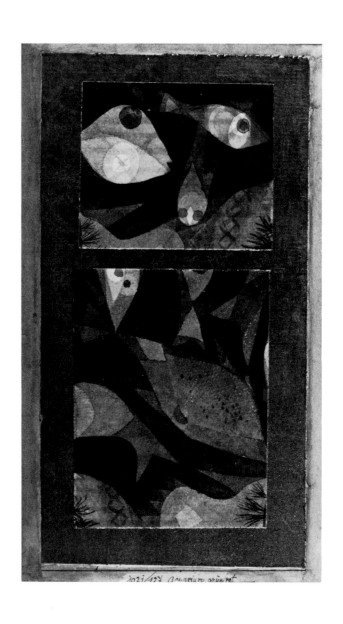

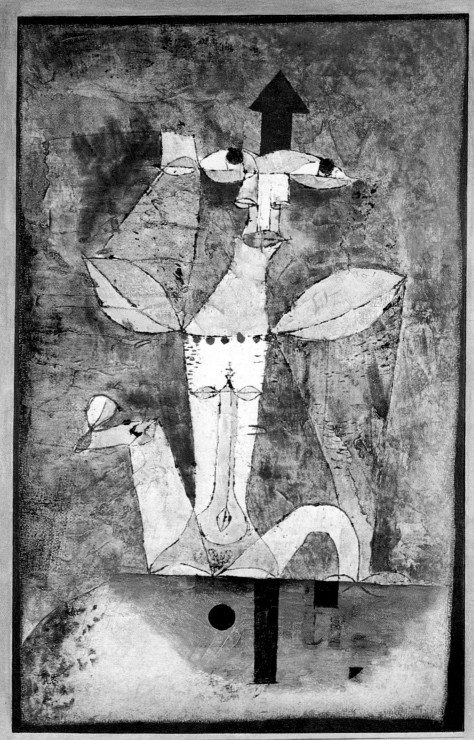

1921/132 Barbaren-Venus.

114

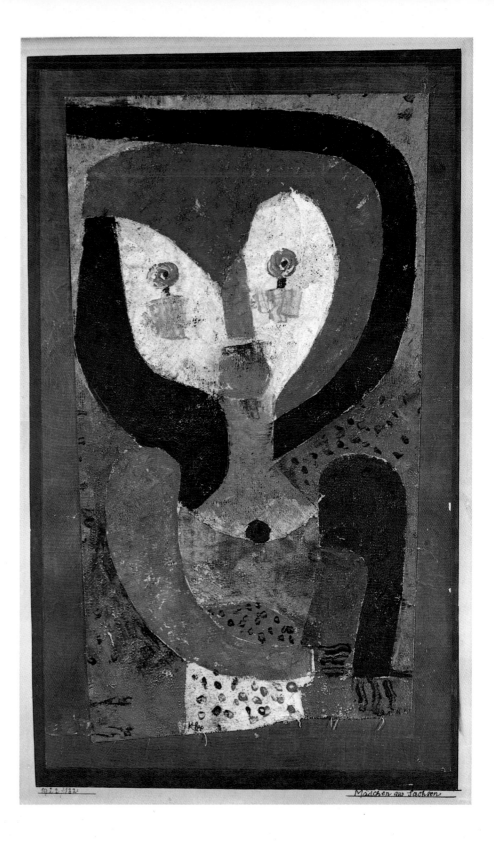

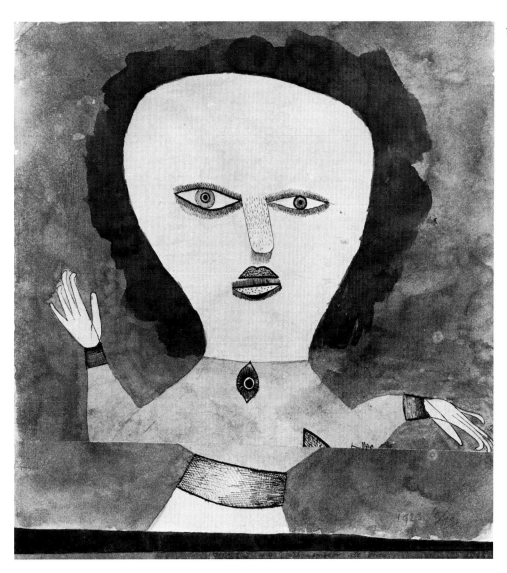

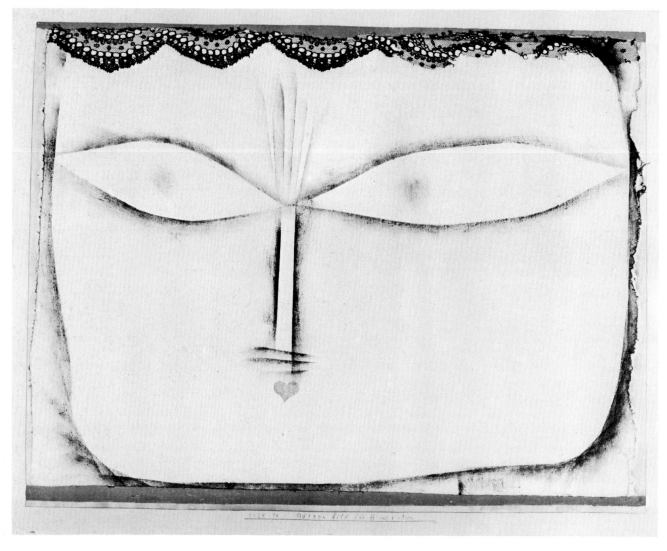

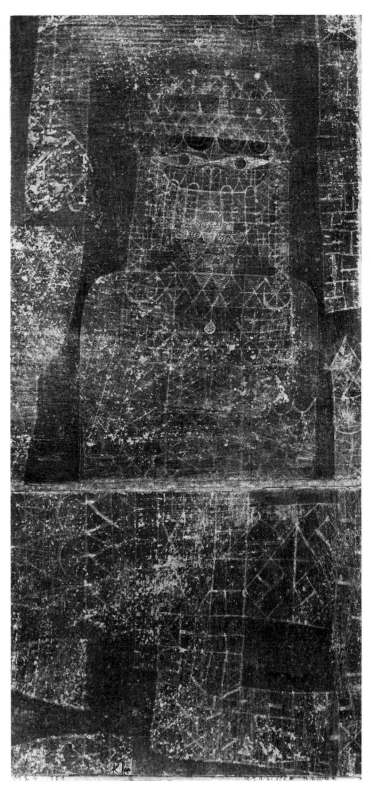

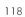

118

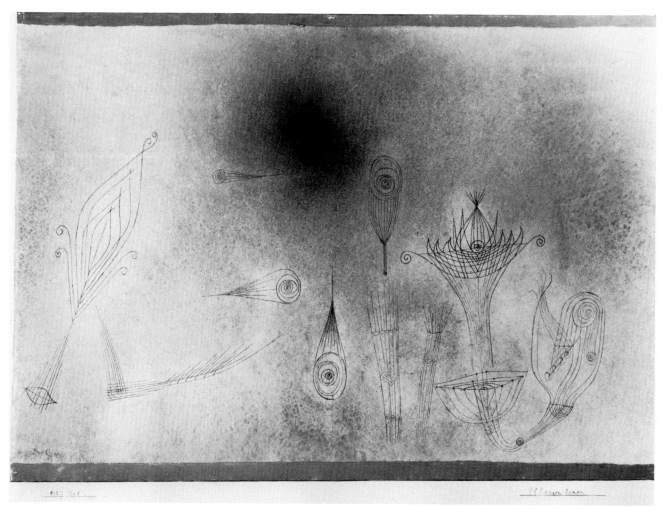

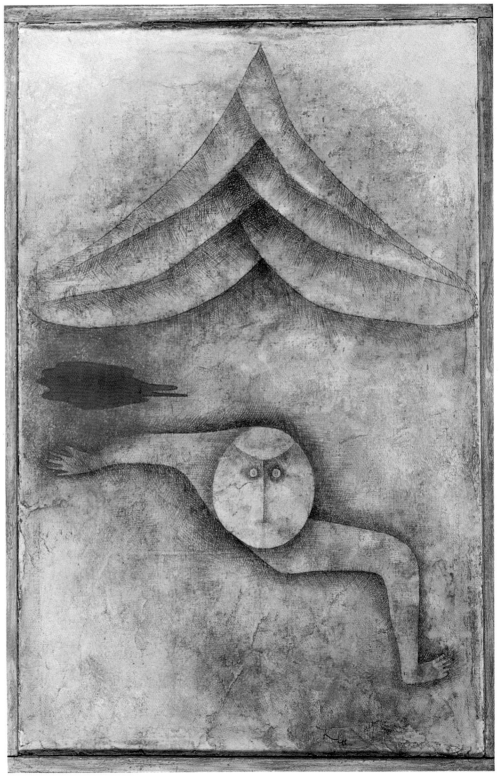

120

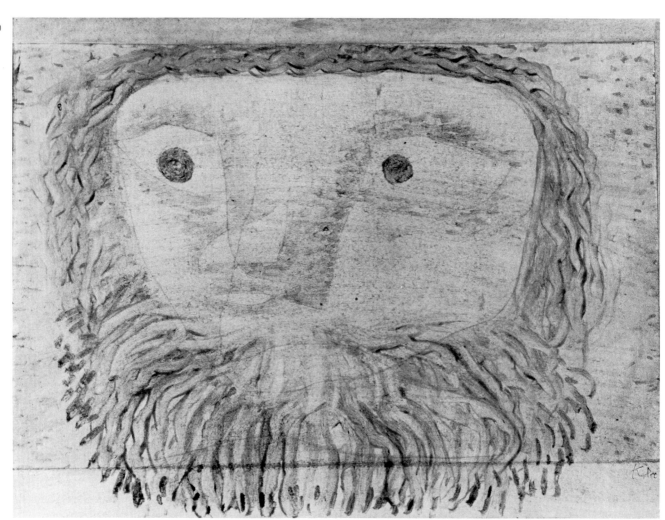

Signed, upper right: *Klee*; dated and inscribed on former mount, *1932.19 Knabe am Tisch* (53.56) Illus. p. 125

284 PLANTS IN THE COURT-YARD (Pflanzen im Hof) 1932
Oil and opaque watercolor on copper-proof paper, formerly mounted on board; 14¾ x 21 in (37.5 x 53.3 cm). Has been remounted on wood composition-board.
Signed, upper left: *Klee*; inscribed on former mount, lower left: *VIII*; dated and inscribed, lower right: *1932 K5 Pflanzen im Hof* (53.58)

285 POSSIBILITIES AT SEA (Mögliches auf See) 1932
Oil and sand on canvas; 38¼ x 37⅝ in (97.2 x 95.5 cm)
Signed, upper right: *Klee*; dated, inscribed, and signed, verso, on former stretcher: *1932.K.6 Mögliches auf See Klee* (53.67) Illus. p. 123

286 BLOSSOMS IN RUINS (Ruinenblüten) 1932
Oil and opaque watercolor on plaster-coated burlap, formerly mounted on board; 11⅝ x 15¼ in (29.5 x 38.6 cm). Has been re-

mounted on wood composition-board.
Signed, upper right: *Klee*; dated and inscribed on former mount, lower left: *VIII 1932.R.1*; inscribed, lower right: *Ruinenblüten* (53.60)

287 A BURNING MAN (Ein Brennender) 1932
Oil, opaque, and transparent watercolor on wrapping paper, mounted on board; comp., 13¾ x 13¾ in (34.9 x 34.9 cm); mount, 16⅛ x 16⅝ in (41.0 x 42.2 cm). Mount has been toned.
Signed, upper right: *Klee*; dated and inscribed on mount, lower center: *1932. R.2 ein brennender* (53.61)

288 TWO HEADS (Zwei Köpfe) 1932
Oil on canvas; 31⅞ x 33⅜ in (81.0 x 84.8 cm)
Signed, upper right: *Klee*; dated and inscribed, verso, on former stretcher: *1932. A.12 Zwei Köpfe* (53.66) Illus. p. 121

289 WEATHERED MOSAIC (Verwittertes Mosaik) 1933
Watercolor on Japanese paper, mounted on board; comp., 13½ x

17⅞ in (34.4 x 45.4 cm); mount, 14 x 18⅜ in (35.6 x 46.7 cm). Mount has been toned and reduced to present size.
Signed, lower left: *Klee*; dated and inscribed on former portion of mount, along lower edge: *1933. L. 19 verwittertes Mosaik* (53.32)

DRAWINGS

290 TWO NUDES, "THE FATHER" (Zwei Akte, "der Vater") 1908
Ink and wash on Ingres paper mounted on board; comp., 6⅜ x 2¼ in (16.2 x 5.7 cm) (irreg.); mount, 9⅜ x 5⅞ in (23.8 x 20.0 cm)
Signed, lower left: *P.K.*; inscribed, lower center: *Der Vater*; dated on mount, lower right: *1908 21* (53.43) Illus. p. 127

291 NUDE FROM BEHIND, WITH CANE (Akt von hinten, mit Stock) 1909
Ink and wash on paper, mounted on board; comp., 5¾ x 2¾ in (14.6 x 7.0 cm) (irreg.); mount, 6¾ x 3½ in (17.1 x 8.8 cm) (irreg.). Mount

124 has been separated from that of number 292 and reduced to present size and shape.
Dated on mount, lower center: *1909/2*
(53.44) Illus. p. 127

292 NUDE, BENDING BACK-WARDS (Akt, sich nach hinten beugend) 1909
Ink and wash on paper, mounted on board; comp., 6⅜ x 4¼ in (16.2 x 10.9 cm) (irreg.); mount, 6¾ x 4¼ in (17.1 x 10.9 cm) (irreg.). Mount has been separated from that of number 291 and reduced to present size and shape.
Dated on mount, lower center: *1909/3*
(53.42)

293 THREE GALLOPING HORSES I (Drei galopierende Pferde I) 1912
Ink on linen paper, mounted on board; comp., 5⅜ x 10⅛ in (13.7 x 25.7 cm) (irreg.); mount, 6 x 10⅝ in (15.2 x 27.0 cm). Mount has been reduced to present size.
Dated and inscribed, lower left: *1912 85a Galopierende Pferde*; signed, lower right: *Klee*
(53.28)

294 LOST IN THOUGHT (Versunkenheit) 1919
Pencil on notepaper, mounted on board; comp., 10⅝ x 7¾ in (27.0 x 19.5 cm); mount, 12¾ x 9⅜ in (32.3 x 23.9 cm)
Signed, upper right: *Klee*; dated on mount, lower left: *1919 75*
(53.22) Illus. p. 128

295 DRAWING FOR SOLITUDE (Zeichnung zur Einöde) 1921
Pencil with incised lines and stippling on drawing paper, mounted on board; comp., 13½ x 10¼ in (34.3 x 26.0 cm); mount, 15¾ x 12 in (40.0 x 30.5 cm)
Dated, upper right: *1921*; signed, lower right: *Klee*; dated and inscribed on mount, along lower margin: *1921/37 Zeichnung zur Einöde (1921/22)*
(53.48)

296 A WALK HAND IN HAND (Spaziergang Hand in Hand) 1921
Ink on notepaper, mounted on board; comp., 8¾ x 6⅞ in (22.3 x 17.4 cm); mount, 12⅞ x 9¾ in (32.7 x 24.8 cm)
Signed, center right: *Klee*; dated and inscribed on mount, lower center: *1921/60 Spaziergang Hand*

in Hand
(53.41)

297 DRAWING FOR "PATHOS OF FERTILITY" (Zeichnung zum "Pathos der Fruchtbarkeit") 1921
Pencil with incised lines and stippling on notepaper, mounted on board; comp., 11⅛ x 8¾ in (28.1 x 22.0 cm); mount, 15¾ x 13½ in (40.0 x 34.3 cm)
Signed, upper left: *Klee*; dated, upper right: *1921*; dated and inscribed on mount, lower right: *1921/ 170 Zeichnung zum "Pathos der Fruchtbarkeit" (21/130)*
(53.47) Illus. p. 129

298 FIRST DRAWING FOR THE SPECTER OF A GENIUS (Erste Zeichnung zum Gespenst eines Genies) 1922
Ink of German Ingres paper, mounted on board; 14⅜ x 7⅝ in (36.5 x 19.5 cm); mount, 15¾ x 7⅝ in (40.0 x 19.4 cm). Mount has been reduced to present size.
Signed, upper left: *Klee*; dated, lower center: *22*; dated and inscribed on mount, along lower edge: *1922///192 erste Zeichnung zum Gespenst eines Genies*
(53.23)

299 GALKA IN THE BAG (Galka in Düt) 1923
Colored pencil on paper; comp., 2⅛ x 2⅜ in (5.4 x 6.0 cm) (irreg.); sheet, 10⅞ x 8⅜ in (27.5 x 21.3 cm)
Inscribed and signed, lower right: *Galka in Düt/Klee*; inscribed, verso: *Was scherimi/ ummi/ Ibi so guet wini/ Derker lider ibi/ Kani nolang werde* [What does one/ think/ I am as good a/ fellow I am,/ the fellow I am,/ I have a long time/ to be]
Composition occurs on page 1 of a two-page letter from ALEXEI JAWLENSKY to Galka Scheyer, signed and dated June 3, 1923, with an untitled, signed ink sketch of a head by Jawlensky also on page 1.
(53.72)

300 PLANTS AND STARS (Pflanzen und Gestirne) 1924
Ink on notepaper, mounted on board; comp., 6¼ x 8⅞ in (15.9 x 22.6 cm); mount, 7⅛ x 9¼ in (18.1 x 23.5 cm)
Signed, upper left: *Klee;* dated and inscribed on mount, lower center: *1924-29 Pflanzen und Gestirne*
(64.38) Illus. p. 130

301 TWO SKETCHES ON A PICTURE POSTCARD ca. 1927
Pencil and colored pencil on color offset lithograph; comps., 1⅝ x 1½ in (4.1 x 3.8 cm), and 1⅝ x 1⅝ in (4.1 x 4.1 cm) (both irreg.); sheet, 5½ x 3⅝ in (14.0 x 19.0 cm)
Inscribed and signed, within one comp.: *Prosit Neu Jahr/ Ihr Klee* [Happy New Year/ your Klee]
Compositions occur on picture-side of a handwritten postcard from LYONEL FEININGER, WASSILY & NINA KANDINSKY, PAUL & LILY KLEE, and GEORG MUCHE to Galka Scheyer, signed by the artists and Mrs. Kandinsky, not dated.
(53.70)

302 GREETINGS TOO FROM A SANDFLEA (Gruss auch vom Sandfloh) 1928
Pencil on paper; comp., 2⅛ x 4 in (5.4 x 10.1 cm) (irreg.); sheet (fragment), 2⅝ x 5⅝ in (6.6 x 14.3 cm) (irreg.) Inscribed, lower right: *Gruss auch vom Sandfloh*
Composition occurs on a fragment cut from page 2 of a two-page holograph letter from LILY KLEE to Galka Scheyer, signed and dated August 13, 1928.
(53.40)

PRINTS

303 CHARM (FEMININE GRACE) [Charme (Weibliche Anmut)] 1904
Etching on heavy paper; impression, 5³⁄₁₆ x 3⅝ in (13.2 x 9.2 cm); sheet, 9 x 6⅝ in (22.8 x 16.9 cm)
Signed, inscribed, and dated in the plate, upper left: *PK Bern Juli/ Nov. 04;* inscribed, upper right: *Inv. 5;* inscribed, lower left: *Charme (weibl. Anmut);* inscribed, within the impression, lower left: *3/30;* signed, dated, and inscribed, lower right: *P. Klee/ 1904.15*
(53.319)

304 PARK 1920
Color facsimile lithograph on medium weight paper; comp., 5 x 4 in (12.7 x 10.2 cm); sheet, 6⁵⁄₁₆ x 5⅞ in (16.1 x 14.9 cm)
Dated and inscribed in the stone, lower left: *1914 145;* signed and inscribed, lower right: *Klee/Park;* signed, in the margin, lower right: *Klee*
Facsimile of a watercolor of 1914
(53.318)

290 Klee Two Nudes, "The Father" 1908

291 Klee Nude from Behind, With Cane
1909

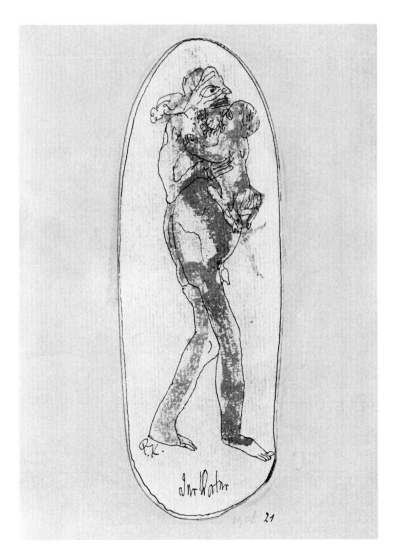

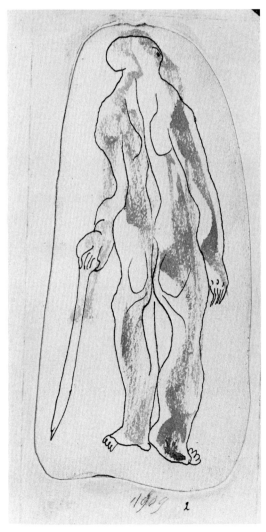

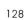

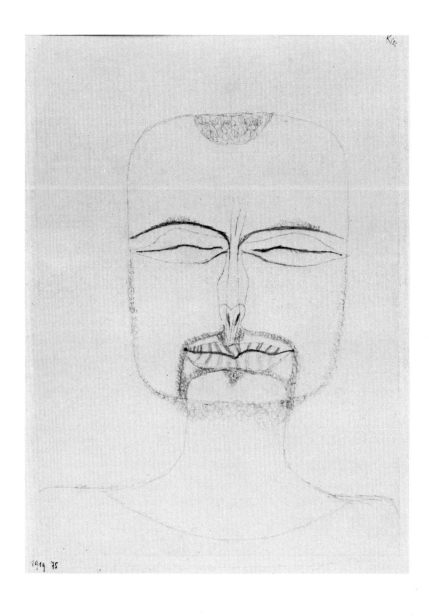

305 THE SAINT OF THE INNER LIGHT (Die Heilige vom inneren Licht) 1921
Lithograph in three colors on German paper; comp., 12³/₁₆ x 6¹³/₁₆ in (31.0 x 17.3 cm); sheet, 13¼ x 7¹³/₁₆ in (33.7 x 19.8 cm)
Dated and inscribed in the margin, lower left: *1921/122 Die Heilige vom inneren Licht*; signed, lower right: *Klee*
(53.46)

306 HOFFMANNESQUE FAIRY TALE SCENE (Hoffmanneske Märchenscene) 1921
Lithograph in three colors on German paper; comp., 12³/₈ x 9 in (31.5 x 22.8 cm); sheet, 13¹⁵/₁₆ x 10³/₈ in (35.4 x 26.5 cm)
Dated and inscribed in the margin, lower left: *1921/123 Hoffmanneske Scene*; signed, lower right: *Klee*
(53.38)

307 BUFFOONERY (Narretei) 1922
Lithograph on vellum; comp., 7½ x 6 in (19.1 x 15.2 cm); sheet, 13 x 9⁷/₈ in (33.0 x 25.1 cm)
Signed and dated in the stone, lower left: *K 1922/68*, with *Klee* pencilled over it; inscribed, dated, and signed, in the margin, lower center: *"Nar-*

retei"/ Litho 13/16 vor der Auflage/ Für Emmy Scheyer Weihnachten 1922 K [Before the edition/ for Emmy Scheyer Christmas 1922 Klee]
(53.316)

308 VULGAR COMEDY (Vulgaere Komoedie) 1922
Lithograph on fibered vellum; comp., 8¾ x 11 in (22.2 x 28.0 cm); sheet, 12¾ x 16⁵/₈ in (32.4 x 42.3 cm)
Signed and dated in the stone, lower right: *K 1922/100*, (with the "K" followed by *lee* in pencil); inscribed in the margin, lower center: *Vulgaere Komoedie Litho 1/10*; inscribed, dated, and signed, lower right: *Für Emmy Scheyer Weihnachten 1922 K* [For Emmy Scheyer Christmas 1922 Klee]
(53.317)

309 THE MAN IN LOVE (Der Verliebte) 1923
Lithograph in two colors on vellum; comp., 10⁷/₈ x 7½ in (27.7 x 19.0 cm); sheet, 13½ x 10¾ in (34.2 x 27.3 cm)
Dated and inscribed in the stone, lower left: *1923 91*; inscribed, lower right: *Der Verliebte*; signed in the margin, lower right: *Klee*; inscribed

and dated, lower center: *Für Emmy Scheyer Dez 23* [For Emmy Scheyer December 1923]
(53.37)

310 TIGHTROPE WALKER (Seiltänzer) 1923
Lithograph in two colors on Japanese paper; comp., 17¼ x 10½ in (43.9 x 26.8 cm); sheet, 19 x 12¾ in (48.2 x 32.4 cm)
Dated, lower left: *23 138*; signed, lower right: *Klee*
(53.39)

OTHER ARTISTS

ALEXANDER ARCHIPENKO
Russian/American 1887-1964

311 SUZANNE (FEMALE NUDE) ca.1909
White limestone sculpture; 18⅝ in (47.3 cm) [including stone base, 3⅛ x 11 x 9⅛ in (8.0 x 27.9 x 23.2 cm)]
(53.250) Illus. p. 134

312 UNTITLED (SEATED FIGURE) 1917
Opaque watercolor on paper; 14 x 11 in (35.5 x 28.0 cm)
Inscribed, signed, and dated, lower right: *à Madame Scheyer/ Archipenko Nice 1917/ 1924/ New York*
(53.191)

313 UNTITLED (FIGURE) 1917
Opaque watercolor on paper; 12⅞ x 9⅞ in (32.5 x 25.1 cm)
Signed, inscribed, and dated, lower right: *Archipenko. Nice 1917*; inscribed, signed, and dated, verso, across upper half: *Et bien . . . (unclear) l'art moderne/ Vive l'art future/ Alexander Archipenko/ New York/ 1924*
(53.256) Illus. p. 135

314 UNTITLED (FIGURE) 1920
Lithograph in four colors on paper;
20 x 13⁹⁄₁₆ in (50.8 x 34.4 cm)
Signed in the stone, lower right: *A. Archipenko*
(53.253)

315 UNTITLED (FIGURE) 1920
Lithograph in three colors on white paper printed brown; 19⅞ x 13½ in (50.5 x 34.2 cm)
Signed in the stone, lower right: *A. Archipenko*
(53.252)

316 UNTITLED (TWO NUDES) ca.1921
Lithograph on paper; 19¾ x 15 in (50.2 x 38.1 cm)
Signed, lower right: *Archipenko*
(53.257)

317 ANGELICA 1922
Etching on paper; impression, 6½ x 4⁵⁄₁₆ in (16.5 x 10.9 cm); sheet, 12¾ x 9¹⁵⁄₁₆ in (32.3 x 25.3 cm)
Signed, lower right: *A. Archipenko*
(53.255)

318 UNTITLED (NUDE) ca.1923
Pastel and pencil on paper; 19⅛ x 13 in (48.6 x 33.0 cm)
Signed, lower right: *A. Archipenko*
(53.254)

ERNEST BLOCK
American composer, born Switzerland 1880-1957

319 UNTITLED (HEAD) n.d.
Watercolor on paper; 10½ x 7¾ in (26.6 x 19.7 cm)
Signed with the artist's monogram, lower right: *EB*
(53.192.1)

320 AMERICAN WOMAN n.d.
Watercolor on paper; 12 x 9 in (30.5 x 22.9 cm)
Inscribed and signed with the artist's monogram, lower right: *"American Woman"* EB
(53.192.2)

321 SUFFRAGETTE n.d.
Watercolor on paper; 12 x 8¾ in (30.5 x 22.3 cm)
Inscribed and signed with the artist's monogram, lower right: *"Suffragette"* EB
(53.192.3)

322 THE BROKEN HEART n.d.
Watercolor on paper; 7 x 5 in (17.8 x 12.7 cm)
Inscribed, lower left: *"The broken heart"*; signed, lower right: *BBB*
(53.192.4)

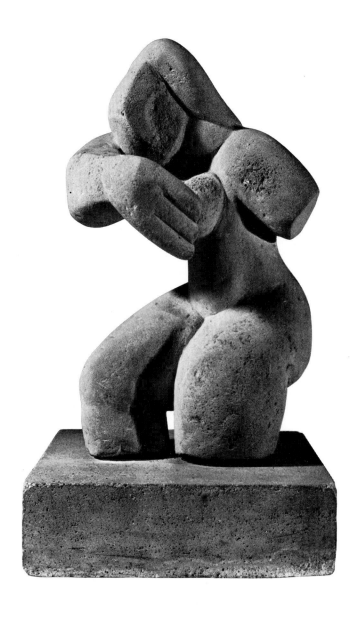

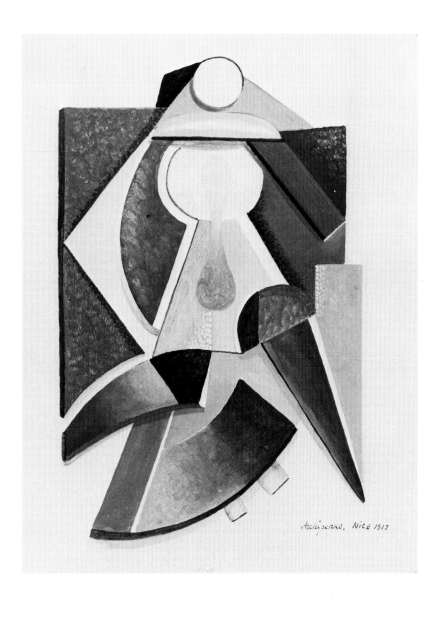

323 UNTITLED (FLOWERING PLANTS IN GREEN GRASS) n.d.
Watercolor on paper; 12 x 8⅞ in (30.5 x 22.5 cm)
Signed with the artist's monogram, lower right: *EB*
(53.192.5)

324 UNTITLED (LANDSCAPE WITH LACY TREES) n.d.
Watercolor on paper; 8⅞ x 12 in (22.6 x 30.5 cm)
Signed with the artist's monogram, lower right: *EB*
(53.192.6)

325 UNTITLED (LANDSCAPE: CONIFERS AT EDGE OF PRECIPICE) n.d.
Watercolor on paper; 7 x 5 in (17.7 x 12.7 cm)
Signed, lower right: *BBB*
(53.192.7)

326 UNTITLED (LANDSCAPE OR UNDERSEASCAPE) n.d.
Watercolor on paper; 6⅞ x 5 in (17.5 x 12.7 cm)
Signed, lower right: *BBB*
(53.192.8)

327 UNTITLED (PRIMITIVE ART IMPULSE) n.d.

Watercolor on paper; 5¾ x 9 in (14.6 x 22.7 cm)
(53.192.9)

328 UNTITLED (LINES AND PLANT FORMS) n.d.
Watercolor on paper; 5¾ x 9 in (14.6 x 22.8 cm)
(53.192.10)

329 UNTITLED (LANDSCAPE: MOUNTAINS INUNDATED BY BLACK AND GREEN SEA) n.d.
Watercolor on paper; 5¾ x 9 in (14.6 x 22.8 cm)
(53.192.11)

330 UNTITLED (REGENERATION) n.d.
Watercolor on paper; 5¾ x 9 in (14.6 x 22.8 cm)
(53.192.12)

331 UNTITLED (LANDSCAPE: VIEW IN THE DISTANCE) n.d.
Watercolor on paper; 11 x 8½ in (27.9 x 21.6 cm)
(53.192.13)

332 UNTITLED (SCENE WITH FIVE FIGURES) n.d.
Watercolor on paper; 7¾ x 10¼ in (19.8 x 26.0 cm)
(53.192.14)

333 UNTITLED (LANDSCAPE: EUCALYPTUS TREES) n.d.
Watercolor on paper; 7 x 5 in (17.8 x 12.7 cm)
(53.192.15)

334 UNTITLED (FLOWERS) n.d.
Watercolor on paper; 10½ x 7¾ in (26.6 x 19.7 cm)
(53.192.16)

335 UNTITLED (PLANTS WITH PURPLE SKY) n.d.
Watercolor on paper; 7¾ x 10⅜ in (19.7 x 26.4 cm)
(53.192.17)

336 UNTITLED (MOUNTAINOUS LANDSCAPE) n.d.
Watercolor on paper; 10⅜ x 7¾ in (26.4 x 19.7 cm)
(53.192.18)

337 UNTITLED (LANDSCAPE WITH LAKE) n.d.
Watercolor on paper; 7⅞ x 10⅜ in (20.0 x 26.4 cm)
(53.192.19)

ANGEL BRACHO
Mexican b. 1911

338 LA NIÑA (GIRL HOLDING YELLOW BASKET) n.d.

Oil on canvas; 62⅞ x 39¼ in (159.7 x 99.7 cm)
Signed, lower left: *Bracho*
(53.193)

339 UNTITLED (WOMAN IN BED WITH FIGURES) 193(0) (unclear)
Lithograph on paper; comp., 12½ x 16⅛ in (31.8 x 41.0 cm); sheet, 13¾ x 18¾ in (35.0 x 47.7 cm)
Signed and dated in the stone, lower right: *Brac . . ./ 193 . . .* (illegible)
(53.194)

IMOGEN CUNNINGHAM
American b. 1883

The twelve photographs which follow were gifts of the artist to the Blue Four Galka Scheyer Collection, 1971, in replacement of unmounted prints from the Estate of Galka E. Scheyer.

340 MAGNOLIA BUD 1925
Photograph mounted on cardboard; print, 9⅜ x 7½ in (23.8 x 19.1 cm); mount, 14½ x 11½ in (36.9 x 29.2 cm)
Signed on mount, lower right: *Imogen Cunningham*
(Ph.71.148)

341 MAGNOLIA BLOSSOM 1925
Photograph mounted on cardboard; print, 8¾ x 11 in (22.2 x 28.0 cm); mount, 14½ x 20 in (36.8 x 50.8 cm)
Signed and dated on mount, lower right: *Imogen Cunningham 1925*
(Ph.71.140)

342 GLACIAL LILY 1927
Photograph mounted on cardboard; print, 9⅜ x 8½ in (23.8 x 21.6 cm); mount, 20 x 15⅛ in (50.8 x 38.4 cm)
Signed and dated on mount, lower right: *Imogen Cunningham 1927*
(Ph.71.143) Illus. p. 156

343 BLACK LILY Before 1929
Photograph mounted on cardboard; print, 9⅛ x 7⅛ in (23.1 x 18.1 cm); mount, 14⅝ x 11½ in (37.1 x 29.2 cm)
Signed on mount, lower right: *Imogen Cunningham*; dated, verso of mount, center: *before 1929*
(Ph.71.146)

344 RUBBER PLANT Before 1929
Photograph mounted on cardboard; print, 12¼ x 9⅞ in (31.0 x 25.0 cm); mount, 20 x 15 in (50.8 x 38.0 cm)
Signed on mount, lower right: *Imogen Cunningham*
(Ph.71.141)

345 CALLA Before 1929
Photograph mounted on cardboard; print, 10⅝ x 8¾ in (27.0 x 22.2 cm); mount, 19⅝ x 15 in (49.8 x 38.0 cm)
Signed on mount, lower right: *Imogen Cunningham*
(Ph.71.139)

346 COLLETIA CRUCIATA Before 1930
Photograph mounted on cardboard; print, 11⅜ x 8¾ in (28.8 x 22.2 cm); mount, 20 x 15 in (50.8 x 38.0 cm)
Signed on mount, lower right: *Imogen Cunningham*
(Ph.71.144)

347 BLACK LILY 1920s
Photograph mounted on cardboard; print, 7⅞ x 9⁹⁄₁₆ in (20.0 x 24.2 cm); mount, 20 x 15⅛ in (50.8 x 38.4 cm)
Signed on mount, lower right: *Imogen Cunningham*
(Ph.71.142)

348 PLANT FORM 1920s
Photograph mounted on cardboard; print, 9⅜ x 7⅜ in (23.8 x 18.8 cm); mount, 14½ x 11½ in (36.8 x 29.2 cm)
Signed on mount, lower right: *Imogen Cunningham*
(Ph.71.147)

349 BLACK AND WHITE LILY
1920s
Photograph mounted on cardboard;
print, 9½ x 7¼ in (24.1 x 18.4 cm);
mount, 14⅝ x 11⅝ in (37.1 x 29.3
cm)
Signed on mount, lower right: *Imo-
gen Cunningham*
(Ph.71.149)

350 CALLA LEAVES 1920s
Photograph mounted on cardboard;
print, 9½ x 7⅜ in (24.1 x 18.8 cm);
mount, 14⅝ x 11½ in (37.1 x 29.2
cm)
Signed on mount, lower right: *Imo-
gen Cunningham*
(Ph.71.150)

351 AGAVE 1920s
Photograph mounted on cardboard;
print, 9½ x 7½ in (24.1 x 18.9 cm);
mount, 14½ x 11½ in (36.8 x 29.2
cm)
Signed on mount, lower right: *Imo-
gen Cunningham*
(Ph.71.145)

VALERE DE MARI
**Architectural decorator, active
in San Francisco ca. 1910-ca.
1930**

352 THE MILLINER 1917
Pastel and crayon on paper; 10⅜ x
12¼ in (26.3 x 31.2 cm)
(53.261)

BORIS DEUTSCH
b. 1895 Lithuania

353 UNTITLED (CONSTRUC-
TIVIST HEAD) ca. 1930
Ink on paper; 9⅝ x 7⅝ in (24.5 x
19.4 cm)
Signed, lower right: *Boris Deutsch*
(53.195)

WALTER DEXEL
German 1890-1973

354 UNTITLED (ARCHITEC-
TURAL DESIGN) 1918
Ink on paper; 8⅝ x 9½ in (21.9 x
24.0 cm)
Signed and dated, lower right: *W.
Dexel 18*
(53.259)

355 UNTITLED (ABSTRAC-
TION) 1922
Woodcut on paper; comp., 7⅝ x
4⅝ in (19.4 x 11.7 cm); sheet, 12 x 9
in (30.5 x 22.8 cm)
Signed in the block, lower left: *D*;
signed and dated in the margin,
lower right: *Walter Dexel 22/ Mai
1922*; inscribed along lower edge:
. . . . *Holzschnitte* . . (illegible)
(53.258)

OTTO DIX
German 1891-1969

356 DAMA 1922
Watercolor on paper; 20¾ x 14⅜
in (52.7 x 36.5 cm)
Signed and dated, lower right: *Dix
22/ 179*; inscribed, verso, lower
right: *Dama*
(53.260) Illus. p. 141

MAYNARD DIXON
American 1875-1946

357 UNTITLED (BUST POR-
TRAIT OF A WOMAN IN PRO-
FILE) 1925
Ink on paper; 4⅜ x 3⅜ in (11.1 x
8.6 cm)

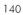

140

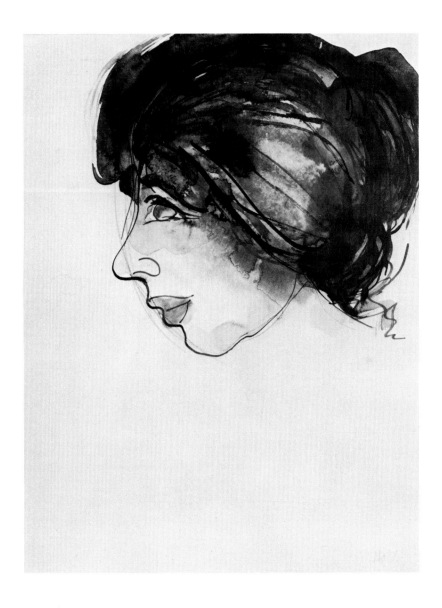

383 Kirchner Two Nudes ca. 1912-13

356 Dix Dama 1922

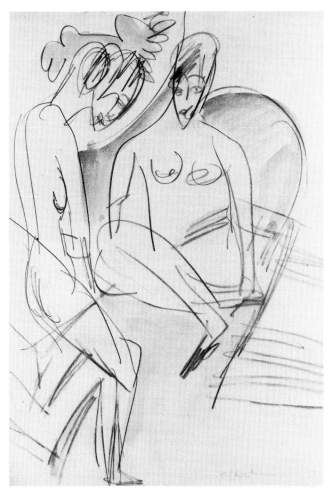

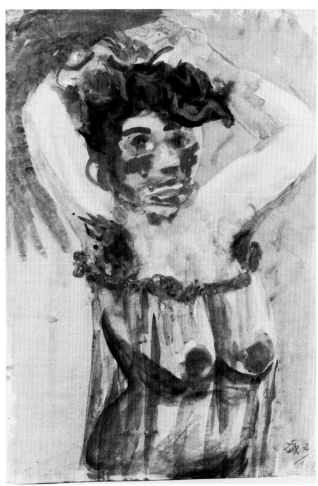

142 Signed, dated, and inscribed, lower left: *M.D./ 1925/ to Mme. Moderne Kunst* [to Mme. Modern Art]
(53.197)

358 UNTITLED (STYLIZED BUST PORTRAIT OF A WOMAN) 1925
Ink on paper; 4 x 3⅜ in (10.1 x 8.6 cm)
Signed and dated, lower left: *MD/ 1925*; inscribed, lower right: *To Mme. Moderne Kunst*
(53.198)

359 UNTITLED (LANDSCAPE) 1925
Ink on paper; 12½ x 10⁷/₁₆ in (31.8 x 26.6 cm)
Signed and dated, lower left: *M.D./ Sept. 1925*
(53.196)

360 UNTITLED (LANDSCAPE WITH BILLOWING CLOUDS) 1925
Ink on paper; 3⅛ x 5 in (7.9 x 12.7 cm)
Signed and dated, lower left: *M.D./ 1925*
(53.199)

361 UNTITLED (THREE FIGURES IN A LANDSCAPE) 1928
Ink on paper, mounted on paper; comp., 4⅜ x 4⅞ in (11.1 x 12.4 cm);

mount, 8 x 10³/₁₆ in (20.3 x 25.9 cm)
Signed and dated, lower left: *MD/ 1928*; inscribed on mount, verso: *In the center of all things we stand/ where the Four Winds of the world come to us singing;/ Their songs we receive in the dawnlight;/ Their songs we receive in the moonlight;/ Their songs we receive in the twilight;/ And the one which comes in the dark night,/ That also we receive, singing*
(53.200)

THEODORE LUX FEININGER
American, born in Berlin, 1910

362 UNTITLED (HEAD) 1923
Polychromed carved wood; 4 x 2 x 1½ in (10.1 x 4.9 x 3.6 cm)
Inscribed (in hand of Lyonel Feininger), on back, near left edge: *LUX FEININGER/ 1923*
(53.190)

ERNST FRICK
Swiss active ca. 1910-1930

363 UNTITLED (HIGHLANDS) 1918
Lithographic crayon on paper; 13½ x 19 in (34.3 x 48.2 cm)
Signed and dated, lower right: *Ernst Frick 18*
(53.262)

364 UNTITLED (ROCKS) 1918
Charcoal on paper; 13⅜ x 18⅞ in (34.0 x 48.0 cm)
Signed and dated, lower right: *Ernst Frick 18*
(53.263)

365 UNTITLED (CHURCH) 1919
Lithographic crayon on paper; 14¾ x 19⅝ in (37.5 x 49.8 cm)
Signed and dated, lower right: (Illegible) *Frick/ 19*
(53.264)

366 UNTITLED (LITTLE CHURCH) n.d.
Crayon on paper; 4⅜ x 5¾ in (11.1 x 14.6 cm)
Signed and inscribed, lower right: *E.F./ Fili Sur*
(53.265)

EDWARD HAGEDORN
American 1902-1937

367 UNTITLED (THE HANGED) 1928
Oil and ink on canvas; 14½ x 11 in (36.8 x 27.9 cm)
Dated, lower left: *3 26 28*; signed, lower right: *E Hagedorn*
(53.267)

368 UNTITLED (NEGRESS) 1928
Gouache and ink on paper; 20 x 12½ in (50.8 x 31.7 cm)
Signed and dated, upper right: *E.H. 28*
(53.266)

369 WELCOME n.d.
Ink on cardboard; 11½ x 12 in (29.2 x 30.4 cm)
(53.269)

370 NUDE n.d.
Ink on paper, mounted on paper; sheet, 10¾ x 7¾ in (27.3 x 19.6 cm); mount, 19⅛ x 12½ in (48.5 x 31.8 cm)
(53.268)

371 UNTITLED (WELCOME III) n.d.
Ink wash on cardboard; 12 x 19⅝ in (30.5 x 49.7 cm)
(53.606)

PAUL HOLZ
German 1883-1938

372 HEAD OF A GIRL (Mädchenbildnis) 1922
Ink and watercolor on paper; 18⅞ x 13¾ in (48.0 x 34.9 cm)

Signed and dated, lower right: *Paul Holz 22*; inscribed, lower center: *Mädchenbildnis*
On reverse: sketch of a human figure and a beast
(53.272)

373 WOMAN WITH VEIL (Frau mit Schleier) 1922
Ink on paper; 19¼ x 15½ in (48.9 x 39.4 cm)
Signed and dated, lower right: *Holz/ 22*; inscribed, lower left: *Frau mit Schleier*
(53.271)

374 MAN WITH TALL HAT AND BLACK BEARD (Mann mit hohem Hut and schwarzen Bart) 1922
Ink and lithographic crayon on paper; 14⅞ x 12⅝ in (37.7 x 32.2 cm)
Signed and dated, lower right: *Holz 22*; inscribed, lower center: *Mann mit hohem Hut/ und schwarzen Bart*
(53.273)

375 UNTITLED (MAN AND BEAST) 1922
Ink and crayon on paper; 22⅛ x 16 in (56.2 x 40.6 cm)
Signed and dated, lower center: *Holz 22*
(53.270)

376 COACHMAN (Kutscher) 1922
Ink on paper; 10⅝ x 10⅜ in (27.0 x 26.4 cm)
Signed, upper right: *Holz*; signed and dated, lower right: *Paul Holz/ 22*
(53.275)

377 UNTITLED (COACHMAN) n.d.
Ink on paper; 11 x 10¼ in (27.9 x 26.0 cm). Paper trimmed to present size.
Signed, lower left: *Paul*; lower right: *Holz*
(53.274)

378 UNTITLED (THE BUTCHER) n.d.
Ink on paper; 12 x 10¾ in (30.5 x 27.3 cm)
Signed, lower right: *Paul Holz*
(53.276)

ANDREI N. JAWLENSKY
b. 1902 Russia

379 PATH TO SIBERIA 1918
Oil on linen-finish paper, mounted on chipboard; 22¾ x 15⅞ in (57.8 x 40.3 cm)
Signed, lower left: *A*; dated, lower right: *1918*
(53.632)

144

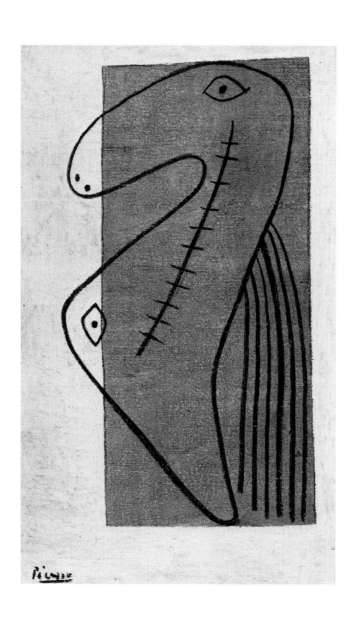

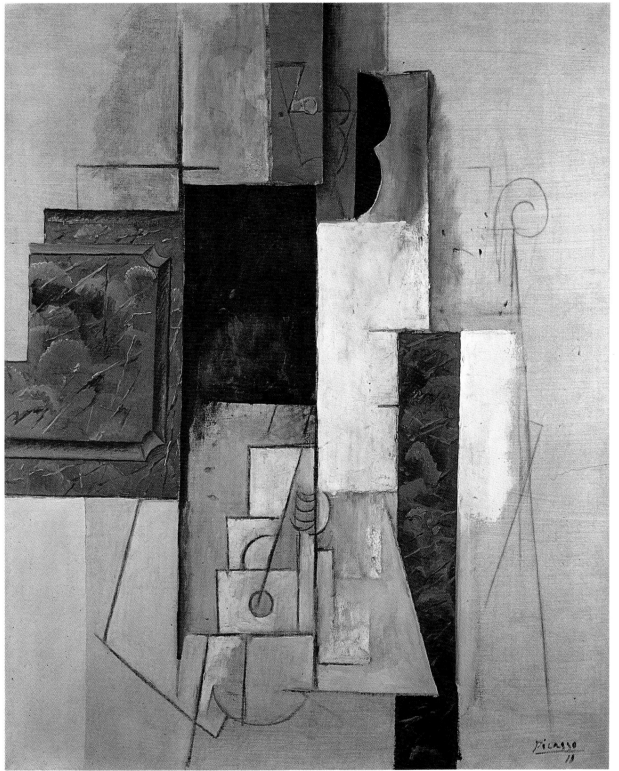

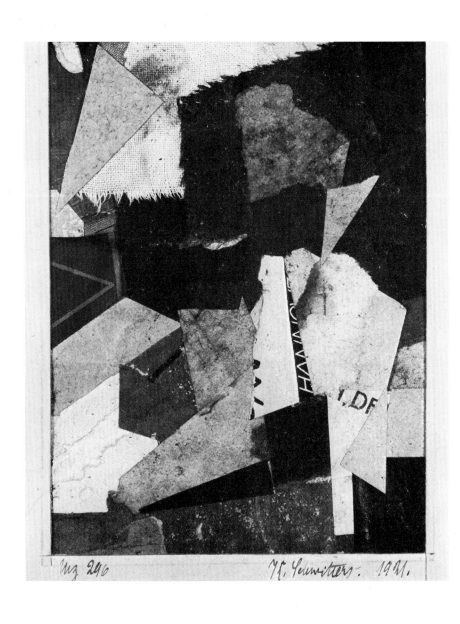

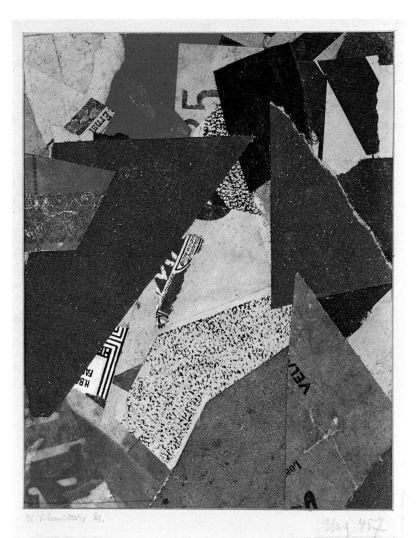

380 LAUSANNE 1918
Oil on cardboard; 5½ x 7⅛ in (14.0 x 18.0 cm)
Signed, lower left: *A*; dated, lower right: *1918*
(53.634)

381 VENISE ca. 1918
Oil on cardboard; 7⅛ x 5½ in (18.0 x 14.0 cm)
(53.633)

382 FLOWERS n.d.
Oil on cardboard; 19⅝ x 15¼ in (49.8 x 38.5 cm)
Signed, lower left: *Andre*
(53.635)

ERNST LUDWIG KIRCHNER
German 1880-1938

383 TWO NUDES ca. 1912-13
Pencil and watercolor on paper; 22 x 16³/₁₆ in (55.9 x 41.1 cm)
Signed, lower right: *E L Kirchner*
(53.277) Illus. p. 141

FELIX KLEE
Swiss, born in Munich 1907

384 UNTITLED 1921
Watercolor on paper, mounted on cardboard; sheet, 6¾ x 10¼ in (17.2 x 26.1 cm); mount, 9½ x 12⅝ in (24.1 x 32.0 cm)
Dated and signed, lower right: *1921/ Felix!*
(53.636)

OSKAR KOKOSCHKA
British, born in Austria 1886

385 HEFA ca. 1922
Lithograph on paper; 25⁹/₁₆ x 19⅛ in (64.9 x 48.5 cm)
Signed, lower left: *O Kokoschka*
(53.278)

386 UNTITLED (BUST PORTRAIT OF A YOUNG GIRL) ca. 1922
Lithograph on paper; 28 x 21³/₁₆ in (71.1 x 53.8 cm)
Signed, lower right: *O Kokoschka*
(53.279)

MARTIN KOSLECK
American, born in Germany

387 OLD WOMAN AT THE MIRROR (Alte Frau am Spiegel) ca. 1938
Oil on canvas; 15¼ x 12 in (38.7 x 30.5 cm)
Signed, lower left: *Kosleck*; inscribed, verso: *Für Galkalein/ (not exclusively for the storage room)/ von Ihrem lieben Kleinen Kos./ "Alte Frau am Spiegel"/ by Kosleck* [from your dear little Kosleck]
(53.637)

388 UNTITLED (TWO FIGURES) n.d.
Oil on canvas board; 8 x 10 in (20.3 x 25.3 cm)
(53.638)

PETER KRASNOW
American, born Ukraine 1890

389 UNTITLED (FIGURE ABSTRACTION) 1928
Pencil on paper; 8½ x 11 in (21.5 x 27.9 cm)
Signed and dated, lower right: *Peter 1928*
Gift of Mrs. Oskar Fischinger, 1962
(62.27)

390 UNTITLED (HEAD RESTING ON ARM) 1928
Pencil on paper; 8½ x 11 in (21.5 x 27.9 cm)
Signed and dated, lower right: *Peter 1928*
Gift of Mrs. Oskar Fischinger, 1962
(62.28)

391 UNTITLED (FIGURES) 1928

Pencil on paper; 8⅞ x 8½ in (22.6 x 21.6 cm)
Signed and dated, lower right: *Peter 1928*
(53.644)

392 SADAKICHI READING POE 1928
Lithograph on paper; 17⅞ x 12⅝ in (45.4 x 32.1 cm)
Inscribed, signed, and dated, upper right: *Sadakichi Reading Poe/ P. Krasnow/ 1928*
(53.639)

393 HEAD 1928
Lithograph on paper; 17⅞ x 12¹/₁₆ in (45.4 x 30.6 cm)
Inscribed, lower left: *head;* signed and dated, lower right: *P. Krasnow 1928;* inscribed and signed, upper left: *head P. Krasnow*
(53.640)

394 UNTITLED (TWO FIGURES CARRYING A LOAD) ca. 1928
Pencil on paper; 8⅜ x 5¹/₁₆ in (21.3 x 12.9 cm)
Signed, lower right: *Peter*
Gift of Mrs. Oskar Fischinger, 1962
(62.29)

395 UNTITLED (THE FAMILY) ca. 1928

Lithograph on paper; 17⅛ x 5 in (43.5 x 12.7 cm)
Signed, lower right: *Kr.;* inscribed and signed, across bottom margin: *Greetings/ Peter Krasnow*
(53.642)

396 UNTITLED (SKETCH OF AN ABSTRACTED NUDE WOMAN) 1919
Pencil on paper; 8½ x 11 in (21.5 x 27.9 cm)
Signed and dated, lower right: *Peter/ 1929*
Gift of Mrs. Oskar Fischinger, 1962
(62.30)

397 UNTITLED (SKETCH OF TWO NUDE FIGURES) 1929
Pencil on paper; 8½ x 9 in (21.5 x 22.7 cm)
Signed and dated, lower right: *Peter 1929*
Gift of Mrs. Oskar Fischinger, 1962
(62.31)

398 THE STALLION 1929
Lithograph on paper; 19⅞ x 17 in (50.5 x 43.2 cm)
Signed and dated, lower right: *Peter 1929*
(53.641)

399 UNTITLED (MAN AND WOMAN EMBRACING) ca. 1929

Pencil on paper; 9 x 8½ in (22.7 x 149 21.5 cm)
Inscribed and signed, lower right: *To you Sweet/ Peter*
Gift of Mrs. Oskar Fischinger, 1962
(62.32)

400 UNTITLED (MAN AND WOMAN EMBRACING) ca. 1929
Pencil on paper; 8½ x 5½ in (21.5 x 14.0 cm)
Signed, lower right: *Peter*
Gift of Mrs. Oskar Fischinger, 1962
(62.33)

401 UNTITLED (MAN STANDING, ONE ARM RAISED) ca. 1929
Pencil on paper; 5½ x 4¼ in (14.0 x 10.8 cm)
Signed, lower right: *Peter*
Gift of Mrs. Oskar Fischinger, 1962
(62.34)

402 UNTITLED (ABSTRAC-TION) ca. 1929
Ink on paper; 8¼ x 5¼ in (21.0 x 13.4 cm)
Signed, lower right: *Peter*
Gift of Mrs. Oskar Fischinger, 1962
(62.35)

403 UNTITLED (ABSTRAC-TION?) n.d.
Woodcut on silver foil; 9⅝ x 4⅝ in (24.5 x 11.7 cm)

Signed, lower right: *P Krasnow*
Gift of Mrs. Oskar Fischinger, 1962
(62.36)

404 RECALLING HAPPY MEM-ORIES n.d.
Watercolor, silver pigment, and pencil on paper; 5 x 6⁷⁄₁₆ in (12.7 x 16.3 cm)
Signed, lower right: *pK*; inscribed, verso, lower right: *Recalling happy memories*
(53.643)

MARIE LAGARIO
Polish b. 1893

405 UNTITLED (FAUN) n.d.
Lithograph on paper; comp., 7³⁄₈ x 7¼ in (18.7 x 18.4 cm); sheet, 12¾ x 9⁷⁄₈ in (32.3 x 25.0 cm)
Signed, lower right: *M. Lagario*
(53.280)

FERNAND LEGER
French 1881-1955

406 SEATED FEMALE NUDE ca. 1908
Ink on colored paper; 12⁵⁄₈ x 9⁵⁄₈ in (32.1 x 24.4 cm)
Signed, lower left: *FL*
(53.282)

EL LISSITZKY
Russian 1890-1941

407 UNTITLED (ABSTRAC-TION) ca. 1922
Pencil, watercolor, and pasted paper on paper; 19⁷⁄₁₆ x 13⅛ in (49.4 x 33.3 cm)
Signed, lower right: *Lissitzky*
(53.283) Illus. p. 152

408 UNTITLED (PROUN) 1923
Lithograph with printed pasted paper on paper; 23¾ x 17³⁄₈ in (60.3 x 44.1 cm)
Signed with artist's monogram, lower right: *El Lissitzky*
(53.284)

409 UNTITLED (PROUN) 1923
Lithograph in two colors on paper; 23¾ x 17⅛ in (60.3 x 43.5 cm)
Signed with artist's monogram, lower left: *El Lissitzky*
(53.285)

410 UNTITLED (PROUN) 1923
Lithograph with printed pasted paper on paper; 23¾ x 17³⁄₈ in (60.3 x 44.1 cm)
Signed with artist's monogram, lower right: *El Lissitzky*
(53.287)

411 GLOBETROTTER (IN TIME) [Globetrotter (in der Zeit)] 1923
Lithograph in four colors on paper; 21¹⁄₁₆ x 18 in (53.5 x 45.7 cm)
Signed with artist's monogram, lower left: *El Lissitzky*
(53.286)

H. LOOSER

412 UNTITLED (RECLINING NUDE) n.d.
Ink on paper, mounted on paper; comp., 9 x 11⁷⁄₈ in (22.9 x 30.3 cm); sheet, 9⁷⁄₈ x 14⅛ in (24.4 x 35.9 cm)
Signed, lower right: *H. Looser*
(53.281)

FRANZ MARC
German 1880-1916

413 UNTITLED (WILD PON-IES) 1912
Woodcut on paper; block, 2³⁄₈ x 3³⁄₁₆ in (6.0 x 8.1 cm); sheet, 4¹³⁄₁₆ x 5⅛ in (11.9 x 13.0 cm)
(53.291)

414 BIRTH OF WOLVES (Geburt d. Wölfe) 1913
Woodcut on paper; 16⁵⁄₈ x 12 in (42.2 x 30.5 cm)
(53.290)

LOUIS MARCOUSSIS
Polish 1883-1941

415 THE CARDPLAYER (Le Joueur) 1921
Lithograph on paper; 9¹¹/₁₆ x 7⅞ in (24.6 x 20.0 cm)
Signed in the stone, lower center: *LM*; signed in the margin, lower right: *Marcoussis*
(53.289)

LAZLO MOHOLY-NAGY
American, born in Hungary 1895-1946

416 CONSTRUCTIONS (Konstruktionen) 1923
Lithograph in two colors on paper; 23¹³/₁₆ x 17⁵/₁₆ in (60.5 x 44.0 cm)
Signed, lower right: *Moholy-Nagy*
(53.294)

417 AL 3 1926
Oil, watercolor, and shellac on sheet aluminum; 15⅞ x 15⅞ in (40.2 x 40.2 cm)
Signed, dated, and inscribed, verso, center: *Al 3 (26)/ Moholy*; signed and inscribed, lower right: *Für Frau Scheyer/ Moholy/ 16/ VIII/ 28*; inscribed, lower center: *"Cinnadratta/ Bum bum bum/ Und lauft*

der/ Ochs im Kreis/ herum!"* [. . . and the beast runs around in circles!]
(53.293) Illus. p. 153

418 UNTITLED ca. 1926
Watercolor, ink, pencil, and pasted paper on paper; 25¾ x 19⅝ in (65.4 x 49.8 cm)
Signed, lower right: *L. Moholy-Nagy*
(53.292) Illus. p. 152

EMIL NOLDE
German 1867-1956

WATERCOLORS

419 THE BLACKSMITH ca. 1910
Watercolor on paper; 13 x 19 in (33.0 x 48.2 cm)
Signed, lower right: *Nolde*
(53.295) Illus. p. 139

420 HEAD ca. 1912
Watercolor and ink on paper; 14½ x 11⅜ in (36.8 x 28.9 cm)
Signed, lower right: *Nolde*
(53.296) Illus. p. 140

421 HEAD OF A PROPHET n.d.
Watercolor on paper, mounted on cardboard; sheet, 16⅛ x 11⅞ in

(41.0 x 30.2 cm); mount, 18⅜ x 14¾ in (47.0 x 37.5 cm)
Signed, lower right: *Nolde*
(53.297)

422 UNTITLED (DANCING GIRL) n.d.
Watercolor on paper; 11¾ x 8⅞ in (29.8 x 22.5 cm)
Signed, lower right: *Nolde*
(53.298)

PRINTS

423 EGYPTIAN (Ägypterin) ca. 1910
Woodcut on paper; image, 6 x 4⅛ in (15.2 x 10.5 cm); sheet, 9⅜ x 6⁷/₁₆ in (23.8 x 16.3 cm)
Signed, lower right: *Emil Nolde*
(53.302)

424 UNTITLED (TWO MEN) ca. 1911
Lithograph on paper; image, 6 x 4¼ in (15.2 x 10.7 cm); sheet, 10⅜ x 8¹¹/₁₆ in (26.3 x 22.1 cm)
Signed, lower right: *Emil Nolde*; numbered, lower left: 6/20
(53.301)

425 MAN AND WOMAN (Mann und Weibchen) ca. 1912
Woodcut on paper; image, 9⅛ x

152

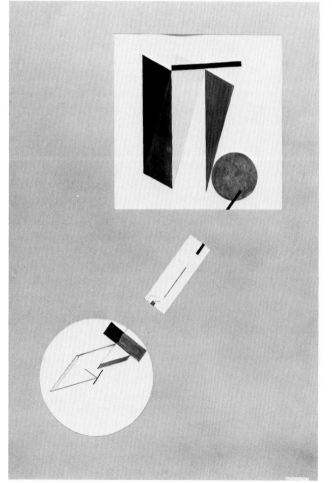

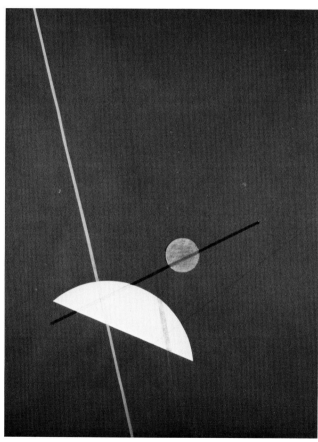

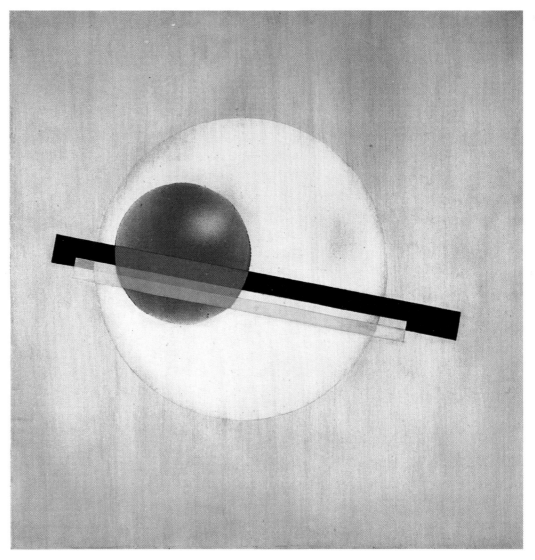

154 11⅞ in (23.2 x 30.2 cm); sheet, 13 x
16¹¹⁄₁₆ in (33.0 x 42.4 cm)
Signed, lower right: *Emil Nolde;*
inscribed, lower center: *Mann u.
Weibchen*
(53.300)

**426 MAN AND GIRL (Mann und
Mädchen) 1918**
Etching with aquatint on paper;
image, 12¹⁄₁₆ x 9⅜ in (30.6 x 23.8
cm); sheet, 24 x 18 in (60.9 x 46.0
cm)
Signed, lower right: *Emil Nolde;*
inscribed, lower center: *Mann u.
Mädchen*
(53.299)

PABLO PICASSO
Spanish 1881-1973

**427 WOMAN WITH A GUITAR
(Femme à la guitare) 1913**
Oil on canvas; 39⅜ x 32 in (100.0
x 81.3 cm)
Signed and dated, lower right:
Picasso/ 13; signed, verso, upper
right: *Picasso*
(53.73) Illus. p. 145

**428 HEAD OF A YOUNG GIRL
ca. 1928**
Oil on canvas; 21¹¹⁄₁₆ x 13¹⁄₁₆ in (55.1
x 33.2 cm)

Signed, lower left: *Picasso*
(53.74) Illus. p. 144

EWALD PLATTE
German b. 1894

**429 UNTITLED (After a Poem by
Baudelaire) 1920**
Watercolor and ink on paper,
mounted on cardboard; 12⅞ x 9¾
in (32.7 x 24.7 cm)
Signed and dated, lower left: *Eu.
Platte/ 20*
(53.303)

FRANZ RADZEWILL
German b. 1895

**430 UNTITLED (WOMAN IN A
LANDSCAPE) n.d.**
Watercolor and pencil on paper;
14⅜ x 19½ in (36.6 x 49.5 cm)
Signed, lower right: *FR*
(53.304)

ANGELO RAVAGLI
Italian

**431 UNTITLED (SCHEYER AND
HER HOUSE) 1936**
Oil on canvas board; 14 x 18 in (35.5
x 45.8 cm)
Signed, dated, and inscribed, lower

right: *Ravagli 1936 XIV;* signed,
inscribed, and dated, verso, upper
right: *Angelo Ravagli/ From An-
gelino to Galketta April 1936*
(53.544)

HANS REICHEL
Austrian 1892-1958

**432 NUMBER 86 (BUST OF A
WOMAN) 1920**
Ink, ink wash, and pasted metallic
paper on paper, mounted on card-
board; paper support, 6³⁄₁₆ x 4⅝ in
(15.7 x 11.7 cm); mount, 11⁵⁄₁₆ x
7¹¹⁄₁₆ in (28.8 x 19.5 cm)
Signed, lower right: *Reichel;* dated,
lower center: *1920 86*
(53.308)

**433 NUMBER 41 (SINKING
STAR) 1921**
Oil on cardboard; 11¼ x 13 in (28.6
x 33.0 cm)
Signed, lower left: *REICHEL;* dat-
ed and inscribed, lower right: *1921/
41*
(53.305)

434 UNTITLED 1922
Etching on paper; impression, 3¹¹⁄₁₆
x 3 in (9.3 x 7.6 cm); sheet, 9¹¹⁄₁₆ x
7⅜ in (24.6 x 18.7 cm)
Signed, in the plate, lower left: *R;*

signed, dated, and inscribed, in the margin, lower left: *REICHEL 1922 8/10;* inscribed and signed, lower right; *Herzliche Wünsche und Grüsse!/ Hans Reichel* [Warmest wishes and greetings!]
(53.306)

435 UNTITLED (SELF POR-TRAIT WITH CIGAR) 1922
Etching on paper; impression, 9¾ x 7¾ in (24.8 x 19.8 cm); sheet, 11⅞ x 9⅛ in (30.2 x 23.2 cm)
Signed and dated, in the plate, lower center: *R/ 1922;* signed and dated, in the margin, lower right: *Reichel/ 1922;* inscribed, lower center: *Für E.E.S.;* inscribed, lower left: *Platte Zerstört!* [plate destroyed!]
(53.309)

436 UNTITLED (TWO BIRDS) 1922
Etching on paper; impression, 7¾ x 9¾ in (19.8 x 24.8 cm); sheet, 9 x 11⁷⁄₁₆ in (22.8 x 29.1 cm)
Signed and dated, in the plate, lower right: *R/ 1922;* inscribed, signed, and dated, in the margin, lower right: *Für E.E.S. Reichel 22*
(53.310)

DIEGO RIVERA
Mexican 1886-1957

437 UNTITLED (BOY EATING A BANANA) 1931
Oil on canvas; 35⅞ x 21¹¹⁄₁₆ in (91.1 x 55.1 cm)
Signed and dated, lower left: *Diego Rivera 1931*
(53.315)

R.M. SCHINDLER
American, born in Austria 1887-1953

438 UNTITLED (CROSSED HANDS) n.d.
Pencil on paper; 8¹³⁄₁₆ x 4¾ in (22.4 x 12.1 cm)
Signed with artist's monogram, lower right
(53.645)

OSKAR SCHLEMMER
German 1880-1943

439 FIGURE DIAGRAM K1 (Figurenplan K1) 1922
Lithograph on paper; 19⅜ x 13⁷⁄₁₆ in (49.2 x 34.1 cm)
Signed and dated, lower right: *O Schlemmer/ 1922*
(53.542)

440 FIGURE H2 (Figur H2) 1922
Lithograph on paper; 19¼ x 13⁷⁄₁₆ in (48.9 x 34.1 cm)
Signed and dated, lower right: *O Schlemmer/ 1922*
(53.543)

KARL SCHMIDT-ROTTLUFF
German b.1884

441 HEAD WITH LOOSE-FLOW-ING HAIR (Kopf mit offnem Haar) 1921
Watercolor and ink on paper; 19 x 15¾ in (48.2 x 40.0 cm)
Signed and dated, lower right: *S Rottluff 1921*
(53.313)

KURT SCHWITTERS
British, born in Germany 1887-1948

442 MERZ 289. ERFURT 1921
Papers, printed papers, watercolor-painted paper, and painted cloth pasted to paper; 8½ x 6⅝ in (21.6 x 14.3 cm)
Signed and dated, lower right: *K. Schwitters. 1921;* inscribed, lower left: *Mz 289/ Erfurt*
(53.314)

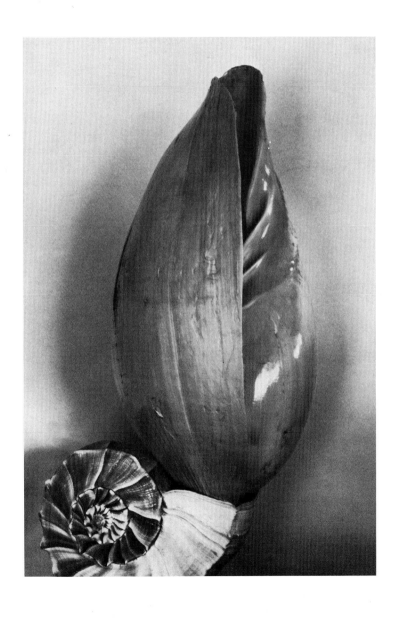

443 MERZ 457 1921
Papers, printed papers, and cloth pasted on paper; 8¾ x 7⁵/₁₆ in (22.2 x 18.6 cm)
Signed and dated, lower left: *K. Schwitters 21*; inscribed, lower right: *Mz 457*
(53.562) Illus. p. 147

444 MERZ 296. SOUP (Merz 296. Suppe) 1921
Papers, printed papers, and cloth pasted on cardboard; 6⁹/₁₆ x 5¼ in (16.8 x 13.3 cm)
Signed and dated, lower right: *K. Schwitters. 1921*; inscribed, lower left: *Mz 296/ Suppe*; inscribed and dated, verso, center: *. . . /fur/ Frau Scheyer/ 6.12.22*
(53.564) Illus. p. 146

445 UNTITLED 1923
Lithograph on paper; 21⅞ x 17½ in (55.5 x 44.4 cm)
Signed, dated, and inscribed, lower left: *K. Schwitters 1923/ Fur Frau E.E. Scheyer./ In Freundschaft auf. 99 Jahre unkundbar am 20.1.24.* [In friendship irrevocable for 99 years on January 20, 1924.]
(53.563)

ARTHUR SEGAL
German, born in Rumania
1875-1944

446 UNTITLED (PICTURE IN BLUE) 1918
Oil on burlap, mounted on canvas; 15½ x 19¾ in (39.4 x 50.2 cm)
Signed and dated, upper right: *A Segall/ 1918*
(53.311)

LASAR SEGALL
Brazilian, born in Russia
1889-1957

447 AT THE DEATH BED (Am Totenbett) 1918
Lithograph on paper; 16⅜ x 17⅞ in (41.6 x 45.3 cm)
Signed and dated, lower right: *Lasar Segall 1918*; inscribed, lower left: *Am Totenbett*
(53.312)

LUCRETIA VAN HORN
American

448 UNTITLED (PORTRAIT OF GALKA SCHEYER) ca.1928-30
Lithographic pencil on paper; 12⅝ x 9½ in (32.0 x 24.1 cm)

Signed, lower right: *Van Horn*
(53.565)

FRANK VAN SLOUN
American 1879-1938

449 UNTITLED (THREE FIGURES — "STARTED WITH AN ARGUMENT") ca. 1925-30
Ink on paper, mounted on cardboard; sheet, 9½ x 7⅝ in (24.1 x 19.4 cm); mount, 14½ x 11½ in (36.8 x 29.2 cm)
Signed, lower right: *F. Van Sloun*; inscribed and signed, lower center: *Started with an argument/ Wound up with an argument/ but as friends/ F. Van Sloun*
(53.646)

BRETT WESTON
American b.1911

450 UNTITLED (LILY) 1926
Black and white photograph, mounted on cardboard; print, 3¾ x 3 in (9.5 x 7.5 cm); mount, 11 x 9 in (27.9 x 22.9 cm)
Signed on mount, lower right: *Brett Weston*
(Ph.53.609c)

EDWARD WESTON
American 1886-1958

451 UNTITLED (HEAD OF NAPA CABBAGE) 1927
Black and white photograph, mounted on cardboard; print, 9½ x 7½ in (24.1 x 18.9 cm); mount, 18½ x 15½ in (47.0 x 39.4 cm)
Signed and dated on mount, lower right: *Edward Weston/ 1927*
(Ph.53.609f)

452 UNTITLED (SHELL PROTRUDING FROM NECK OF CLAY JAR) 1927
Black and white photograph, mounted on cardboard; print, 9⅝ x 7½ in (24.3 x 19.0 cm); mount, 18½ x 15½ in (47.0 x 39.4 cm)
Signed and dated on mount, lower right: *Edward Weston/ 1927*
(Ph.53.609g)

453 UNTITLED (TWO SHELLS) 1927
Black and white photograph; 9⅜ x 6½ in (23.8 x 16.5 cm)
Inscribed, signed, and dated, verso, lower right: *Con muchos recuerdos/ Eduardo / Edward Weston / 1927* [Thinking of you always/Edward]
(Ph.53.609b) Illus. p. 157

454 UNTITLED (PEPPER) 1930
Black and white photograph, mounted on cardboard; print, 7½ x 9⅜ in (19.0 x 23.8 cm); mount, 15 x 15⅝ in (38.1 x 39.7 cm)
Signed and numbered on mount, lower left: *EW 6/50*; signed and dated, lower right: *Edward Weston — 1930*
(Ph.53.609e)

455 UNTITLED (KELP) 1930
Black and white photograph, mounted on cardboard; print, 7⅝ x 9⅝ in (19.2 x 24.3 cm); mount, 15 x 15⅝ in (38.1 x 39.6 cm)
Signed and numbered on mount, lower left: *EW 7/50*; signed and dated, lower right: *Edward Weston 1930*
(Ph.53.609d)

456 THE DUNES, OCEANO 1936
Black and white photograph, mounted on cardboard; print, 7⅝ x 9½ in (19.3 x 24.1 cm); mount, 14½ x 15½ in (36.7 x 39.4 cm)
Signed and dated on mount, lower right: *Edward Weston 1936*; inscribed, signed, and dated, verso of mount, center: *To Galka/ who first told me/ about the Dunes/ Edward/ 1936*
(Ph.53.609a)

WOLO VON TRUTZSCHLER
American, born in Berlin 1902

457 UNTITLED (CARICATURE OF GALKA SCHEYER) 1935
Oil pastel on paper; 19 x 12 in (48.2 x 30.4 cm)
Signed and dated, lower right: *Wolo/ 35*; inscribed, lower left: *To Galka Scheyer/ from Wolo/ for Easter!!!*
(53.607)

159

Photograph credits:

Galka Scheyer and Alexei Jawlensky *Lette Valeska,* 2
Galka Scheyer *Alexander Hammid,* 8